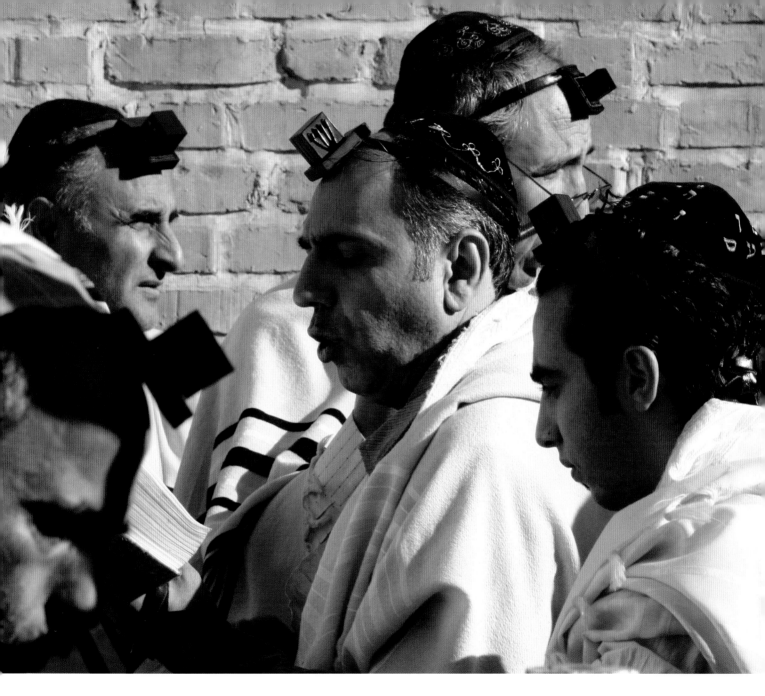

Jews of Iran

DIMYONOT דמיונות
Jews and the Cultural Imagination

Samantha Baskind, General Editor

Volumes in the Dimyonot series explore the intersections, and interstices, of Jewish experience and culture. These projects emerge from many disciplines—including art, history, language, literature, music, religion, philosophy, and cultural studies—and diverse chronological and geographical locations. Each volume, however, interrogates the multiple and evolving representations of Judaism and Jewishness, by both Jews and non-Jews, over time and place.

OTHER TITLES IN THE SERIES:

David Stern, Christoph Markschies, and Sarit Shalev-Eyni, eds., *The Monk's Haggadah: A Fifteenth-Century Illuminated Codex from the Monastery of Tegernsee, with a prologue by Friar Erhard von Pappenheim*

Ranen Omer-Sherman, *Imagining the Kibbutz: Visions of Utopia in Literature and Film*

Jordan D. Finkin, *An Inch or Two of Time: Time and Space in Jewish Modernisms*

Ilan Stavans and Marcelo Brodsky, *Once@9:53am: Terror in Buenos Aires*

Ben Schachter, *Image, Action, and Idea in Contemporary Jewish Art*

Heinrich Heine, *Hebrew Melodies*, trans. Stephen Mitchell and Jack Prelutsky, illus. Mark Podwal

Irene Eber, *Jews in China: Cultural Conversations, Changing Perspectives*

Jonathan K. Crane, ed., *Judaism, Race, and Ethics: Conversations and Questions*

Yael Halevi-Wise, *The Multilayered Imagination of A. B. Yehoshua*

David S. Herrstrom and Andrew D. Scrimgeour, *The Prophetic Quest: The Windows of Jacob Landau, Reform Congregation Keneseth Israel, Elkins Park, Pennsylvania*

Laura Levitt, *The Afterlives of Objects: Holocaust Evidence and Criminal Archives*

Lawrence Fine, ed., *Friendship in Jewish History, Religion, and Culture*

Jews of Iran

A Photographic Chronicle

Hassan Sarbakhshian,
Lior B. Sternfeld,
and Parvaneh Vahidmanesh

The Pennsylvania State University Press

University Park, Pennsylvania

Physiographic map of Iran from the Central Intelligence Agency (https://www.cia.gov/resources/map/iran/)

Library of Congress Cataloging-in-Publication Data

Names: Sarbakhshian, Hassan, 1968– author. | Sternfeld, Lior B., 1979– author. | Vahidmanesh, Parvaneh, 1980– author.
Title: Jews of Iran : a photographic chronicle / Hassan Sarbakhshian, Lior B. Sternfeld, and Parvaneh Vahidmanesh.
Other titles: Dimyonot (University Park, Pa.)
Description: University Park, Pennsylvania : The Pennsylvania State University Press, [2022] | Series: Dimyonot : Jews and the cultural imagination | Includes bibliographical references and index.
Summary: "A photographic exploration of life in the Jewish communities of Iran"—Provided by publisher.
Identifiers: LCCN 2021061809 | ISBN 9780271092645 (hardback)
Subjects: LCSH: Jews—Iran—Pictorial works. | LCGFT: Illustrated works.
Classification: LCC DS135.I65 S27 2022 | DDC 955/.004924—dc23/eng/20220111
LC record available at https://lccn.loc.gov/2021061809

Published by The Pennsylvania State University Press,
University Park, PA 16802–1003

The Pennsylvania State University Press is a member of the Association of University Presses.

It is the policy of The Pennsylvania State University Press to use acid-free paper. Publications on uncoated stock satisfy the minimum requirements of American National Standard for Information Sciences—Permanence of Paper for Printed Library Material, ANSI Z39.48–1992.

This book is dedicated to our families, immigrants, refugees, and displaced people wherever they are.

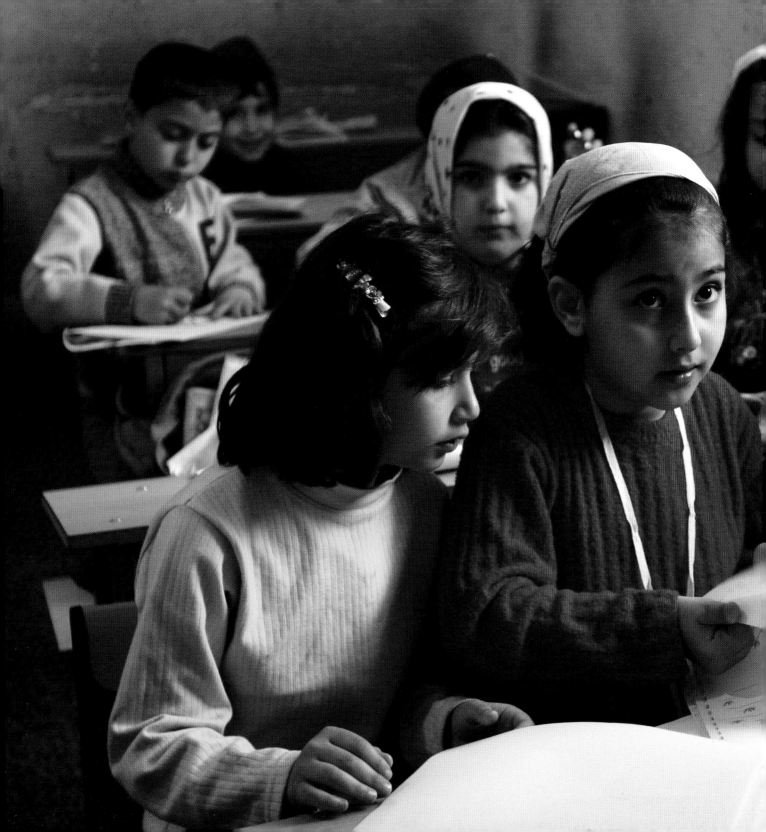

Contents

Acknowledgments

Working on this project showed us the meaning of "global village." The project's inception was in Tehran, in the first eventful decade of the third millennium. A few years later, it started to take another shape in a restaurant in College Park, Maryland. In the years of working on this book, we took to the roads in Israel and Czechia, and now when this book is finally ready to see the light of day, we want to thank everyone who helped us.

First, we would like to thank our families for lending us the support and time to work on this project. We want to thank Ida Meftahi for making the initial introduction while sitting in that restaurant in Maryland, and Houman Sarshar for advising. At Penn State University Press, we want to thank Patrick Alexander for enthusiastically supporting this project from the very beginning. Likewise, we want to thank Alex Vose and Josie DiNovo for seeing the project through. The production became possible thanks to the generous support of the Department of History and the Jewish Studies Program at Penn State and the people who led these units during the process, Michael Kulikowski and Ben Schreier. My gratitude goes to my research assistant at Penn State, Jocelyn Krieger, who made sure to put everything in order and see all the moving parts, including those in the emails that I continuously missed.

Hassan and Parvaneh wish to thank Parviz Minaee, who helped us find real people to meet and different places to cover, and without whose bits of help this book would never have happened; Farhad Aframian, a leader in the Jewish community, who arranged many of the permissions to cover ceremonies and events; Farhad Moradian, an Iranian Israeli teacher at Tel Aviv University, who always opened locked doors for us; the family of Saketkhu, whose trust and collaboration were essential for the success of this project; and last but not least Hertzel Gidaian, an Iranian carpet trader, who let us into his business and home.

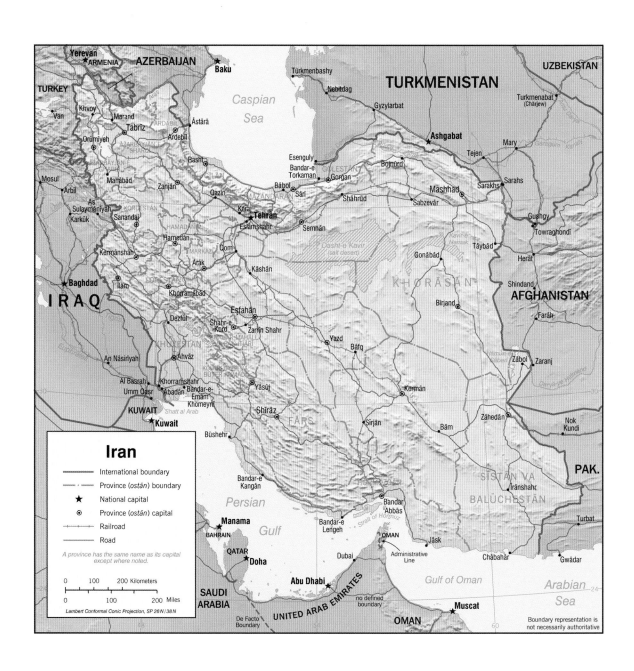

Iran

- International boundary
- ·— · — Province (ostān) boundary
- ★ National capital
- ⊙ Province (ostān) capital
- ┼┼┼┼ Railroad
- ———— Road

*A province has the same name as its capital
except where noted.*

0 100 200 Kilometers

0 100 200 Miles

Lambert Conformal Conic Projection, SP 26N/38N

TURKEY
ARMENIA
Yerevan ★
AZERBAIJAN
Baku ★
Caspian Sea
TURKMENISTAN
UZBEKISTAN
Türkmenbashy
Nebitdag
Gyzylarbat
Ashgabat ⊙
Turkmenabat
(Chärjew)
Tejen
Mary

Van
Khvoy
Marand
Tabrīz
Ardebīl
Āstārā
Esenguly
Bandar-e Torkaman
GOLESTAN
Bojnūrd
Sarakhs
Sarahs

Orūmīyeh
Mosul
Arbīl
As Sulaymānīyah
Karkūk
Mahābād
Rasht
Qazīn
Bābol
Sārī
Gorgān
Shāhrūd
Mashhad
Sabzevār
Gushgy
Towraghondī

Sanandaj
Zanjān
Karaj
Tehrān ★
Eslāmshahr
Semnān
Kavīr-e Namak
Tāybād
Herāt

Kermānshāh
Hamedān
Qom
Dasht-e Kavir
(salt desert)
Gonābād
Shindand
AFGHANISTAN

Baghdad ★
Īlām
Arāk
Kāshān
KHORĀSĀN

IRAQ
Khorramābād
Esfahān
Shahr-e Kord
Zarrīn Shahr
Yazd
Bāfq
Bīrjand
Farāh

Dezfūl
Yāsūj
Zābol
Zaranj

An Nāsirīyah
Ahvāz
Kermān
Zāhedān

Al Basrah
Umm Qasr
Khorramshahr
Abādān
Bandar-e Emām Khomeynī
Shīrāz
Sīrjān
Bām
Nok Kundi

KUWAIT
Shatt al Arab
FĀRS
SĪSTĀN VA BALŪCHESTĀN
PAK.

Kuwait ★
Būshehr
Bandar-e Kangān
Īrānshahr

Manama ★
BAHRAIN
Persian Gulf
Bandar-e Lengeh
Bandar Abbās
Turbat

QATAR
Doha ★
Dubai
OMAN
Administrative Line
Jāsk
Châbahār
Gwādar

SAUDI ARABIA
Abu Dhabi ★
UNITED ARAB EMIRATES
no defined boundary
Gulf of Oman
Arabian Sea

De Facto Boundary
OMAN
Muscat ★
Boundary representation is not necessarily authoritative

Introduction

Iranian Jews in the Twenty-First Century

In 2020 the layperson would find it rather surprising that the biggest Jewish community in the Middle East outside Israel lives in what is perceived to be the archenemy of Israel and Jews: Iran.[1] The modern history of this ancient Jewish community is fascinating and dramatic, complicated and beautiful, as would be expected of a community that has been around for 2,700 years. The regional tension between Israel and Iran turned Iranian Jews into a matter of great concern, as both sides have used the existence of this community to advance their policies and agendas. However, for us to truly understand the situation of these communities, we must look beyond clichés and false narratives. We typically try to understand Iran through concepts and images provided to us by popular culture and media. Unfortunately, these sources do little justice to the reality.

Jews have lived in Iran since the Babylonian exile, some 2,700 years ago. The harsh rhetoric between Israel, the Jewish homeland, and Iran—especially since 1979—has obscured the importance of this community. Since the 1979 revolution, the well-being of this community has become an issue of great concern, and our ability to understand Iran in general—and Iranian Jews more specifically—has been harmed by the political situation and the media representation of it. We frequently draw on other historical events to make sense of what we cannot otherwise rationally explain.[2] Often, because of movies and books such as *Not Without My Daughter* (not about Jews, but set in Iran with Western participants) or *The Septembers of Shiraz*, Iranian

Jews are perceived to be trapped in Iran with no way out. This community, however, decides every day to remain in the country that they have called home for nearly three millennia.

Our story begins at the turn of the twentieth century with the 1906–11 Constitutional Revolution. This revolution turned Iranians, for the first time, from subjects into citizens, at least nominally. And for Iranian Jews—and other minorities—the promise was great: to make them an equal part of Iranian society. The process was not painless, and in many ways it never came to completion. In the first Majlis (the Iranian parliament), Jews (and other recognized minorities—with the exception of only the Zoroastrians) were not allowed to represent themselves and were pushed to "elect" Muslims to represent them (Afary 1996, 70). In the last years of the Qajar dynasty (r. 1795–1925) Jews tried to maximize their rights amid the promise of the constitutional period. In those years more and more of the Alliance Israélite Universelle schools opened their doors, trying to train Iranian Jews and help them develop skills that would help them achieve upward mobility on the social ladder. Alliance Israélite Universelle schools taught languages and writing, which gave the members of the community some advantages in trade, bureaucracy, and access to higher education and training in Iran and abroad. In the years between the beginning of the constitutional period and World War I, Jews came to realize that the legal barriers were not the only things standing between them and social assimilation. But with World War I brewing and the emergence of political Zionism, things started to change for Iranian Jews in unexpected ways.

The message of political Zionism first struck a chord with Jewish Iranians in 1917, following the Balfour Declaration, which promoted a Jewish homeland (Levī 1999, 510). Newly disillusioned with the outcome of the Constitutional Revolution, all of a sudden the promise of relocating to a place of their own sounded rather tempting. Iranian Jews thus established Zionist associations to teach Hebrew and handle the preparations for a mass exodus. However, shortly afterward, in 1925, with the ascendance of Reza Pahlavi as the new shah (r. 1925–41), Jews shelved their plans for relocation. Reza Shah overthrew the Qajar dynasty and sought to implement a new national project envisioning an Iranian society in which religion and religious

identity were secondary, similar to that of Mustafa Kemal Ataturk in the new Republic of Turkey. Reza repealed all laws that barred Jews (and other minorities) from living in certain areas, from engaging in some occupations, and from joining the army, for example. Jews became an equal part of the Iranian society. Zionism largely remained underground, though; Zionist organizations could operate openly in some fields but were banned in others altogether.

Sympathies to Zionism and different interpretations of Zionism started to split the communities in the 1920s. Shmuel Hayyim, a leader in the Jewish community, a Zionist, and the Jewish representative to the Majlis, had a harsh disagreement with another Jewish dignitary, Loqman Nahurai, who had also served as the Jewish deputy in the Majlis before and after Hayyim's tenure. Nahurai espoused the view that Jews should join the Zionist international organizations in full force, but Hayyim believed that while Zionism was overall a positive development, Iranian Jews should fight for their rights and status in Iran and not forfeit it for any messianic dream. Hayyim published a newspaper in Hebrew called *Ha-Hayyim* (Life), in which he advocated for integration, participation in political life, and the development of a national consciousness within Iran. Hayyim was eventually executed by Reza Shah on the basis of the mostly false accusation that Hayyim was complicit in an attempt to assassinate the shah. In any case, following this incident, all non-Iranian organized movements were banned from operating in Iran.

In 1941, during World War II, the Allied Armies invaded Iran. Britain and the Soviet Union occupied Iran, deposed Reza Shah, and installed his son Mohammad Reza Pahlavi as the new shah (r. 1941–79). During the first years, most of them while British and Soviet forces still occupied the country, political forces from the right and the left that had been banned under Reza Shah's regime were able to resume activities. We see in this period the beginning of the Tudeh Party, the Iranian Communist Party, in 1941, as well as nationalist right-wing parties (some were decisively fascist) like SUMKA and Pan-Iranist. Many Jews joined the Tudeh Party to combat social ostracism, which had become a divisive issue in the period in which Iranian national identity had started to take shape. Iranian communism differed dramatically from European communist parties especially in matters of loyalty to the Soviet Union, the importance of class

warfare, and secularism. For Jews and others, supporting the Tudeh Party meant supporting the anti-Fascist forces in Iran, fighting racism and anti-Semitism, and struggling for social equality. These motivations drove the younger generation to support this party.

At the same time we see Zionist and Israeli involvement in Jewish life in Iran. Zionist clubs and youth movements were active; however, Iranian youths did not engage Zionism as Israeli officials had hoped. Indeed, Zionism had become more complex than it had been in 1917. The twenty-five thousand Iranian Jews who had immigrated to Israel around 1948–51 were the poorest and neediest of the Iranian Jewish communities. But myriad stories at that time circulated about Jews who had emigrated from Iran to Israel and returned or wanted to return; the important thing was that Iranian Jews overall had a sober idea of what the practice of Zionism in Israel looked like in reality, rather than the ideal (unlike many of the other Middle Eastern Jews). A telling example is given in a 1951 report by Stanley Abramovitch, a director in Iran of the American Jewish Joint Distribution Committee, one of the most important international Jewish aid organizations. Abramovitch describes one instance of Jews from Nehavand:

> The letters that come from Israel dampen all spirits. The Iranian Jew is not the Halutzic [pioneer] type. The ordeals of present day life in Israel have left him discouraged, longing to return to his damp dark ghetto room, for he has been used to that room and even liked it. Food is available in Iran, and though he earned little he lived in an environment, which was not strange to him. The language, the people, the life was familiar, Israel is not. As a Persian he is looked down upon. [. . .] The letters that come back to Iran complain about the shortage of food. Nehavand received a letter and Thora [Torah] scroll from their brethren in Israel. The Nehavand Jews in Israel signed their names on this piece of scroll and in the accompanying letter they wrote that they took an oath by the Thora from which they sent a piece, that their brethren in Nehavand will not come to Israel now, anyway not until they inform them that the time is more suitable. And Nehavand is a God-forsaken place in the mountains

of Loristan, cut off from the outside world. [. . .] Yet their "Landsleit" [Yiddish for Landsmen] in Israel advise them, adjure them to remain in Nehavand. Another family was advised not to leave for Israel until their son Joseph is married. Joseph is one year old. (Abramovitch 1951)

Inevitably, after 1948 the issues of Zionism and the state of Israel became inseparable from other Jewish matters in Iran, no matter from which end of the spectrum—Zionist or non-Zionist. Zionism had become increasingly important because the shah's grand vision for Iran entailed alliances with the West and with Israel. Israel, as a Western country, represented much of what the shah envisioned for his country. Iranian Jews, by association with Israel and by extension, became more vital and instrumental to his nation-building project than he had perhaps intended.

Community institutions such as Jewish schools had become very influential in shaping the Jewish-Iranian identity—for example, the Alliance Israélite Universelle; ORT (Obshestvo Remeslennogo i zemledelcheskogo Truda [The Society for Trades and Agricultural Labor], originally a Russian network of vocational schools); and Ittefaq (Agreement), the Jewish-Iraqi school in Tehran. These schools excelled in preparing their students for professional life in Iran, and in the 1960s Ittefaq was ranked the number one school in Iran in success rates in the national university entrance exams. Naturally, the Jewish schools were seen by many non-Jews as vehicles for social mobility. Indeed, in the 1960s and 1970s more and more non-Jews enrolled in those schools. So at that time, Iranian society was invested in cultural and social life for Jews, Jewish schools were preparing the next generation of young Iranian professionals, and at the universities Jews joined Jewish and non-Jewish student associations—some of them political (i.e., opposition), others more cultural and literary.

With the amelioration of their financial and social status, many Iranian Jews thought fondly of Israel and thought that Zionism was good—but for other people, who could not live in their homelands. This was definitely not the case for the Jews of Iran. They had become fully Iranians.

They espoused an identity that combined two or more ingredients. One could be Iranian nationalist, Communist, and Zionist all at the same time (especially before 1967). But their Zionism was not necessarily political Zionism but rather spiritual Zionism, one that is related more to the sanctity of the Land of Israel than to the political rights of Jews and others in Iran. The Jewish Agency (the political branch of the Zionist Organization) and the Israeli government realized this and between 1965 and 1969 decided to effectively end the attempt to bring Iranian Jewry en masse to Israel. Attempts to encourage Iranian *aliyah* (immigrating to Israel) had become unfruitful, just as with American Jews, Australian Jews, and South African Jews.

But Israel had a substantive presence in Iran, which also helped Iranian Jews. Israeli companies worked in Iran and had government contracts; they worked in construction, in agriculture, with the military, in industry, and more. And many times, when they needed local employees, these companies hired Iranian Jews, providing further social mobility for the local Jewish community. Regular flights between Tel Aviv and Tehran—eighteen a week on average in the 1970s—helped cultivate this intimate relationship as well.

Let us ponder for a moment the memoir of Elias Eshaqian, a teacher and principal of Alliance schools in Iran for over twenty-five years: "Iran has been my homeland [*vatan*], and Jerusalem has been the source of my belief in God and the direction of my prayers [*qiblah*]" (Isḥaqyan 2008, 441). Here Eshaqian suggests yet again that many Iranian Jews differed from the Jewish Agency in their interpretation of Zionism. For Eshaqian, national Iranian identity did not interfere with his religious identity as a Jew. He proudly projected this combined identity throughout his career, which may have inspired and encouraged his students.

In the same vein, the Iranian-American journalist Roya Hakakian writes in *Journey from the Land of No* about a Passover Seder with her family in 1977:

> Naturally it caused an uproar at the Seder when Father asked Uncle Ardi to read the Ha Lachma [a text from the Passover Haggadah]. Everyone burst into laughter, even before he began. He obeyed and read, but not without a touch of subversion, a bit of mischief:

"'This is the bread of affliction'—some affliction!—'that our forefathers ate in the land of Egypt. This year we are slaves.' May this slavery never end! 'This year here and next year at home in Israel.' Pardon me for not packing!"

[...] The family dreamed of the land of milk and honey but wanted to wake up in Tehran. [...]

After reciting the Ha Lachma, Uncle Ardi asked, "So, Hakakian, are your bags packed or is the flight to Jerusalem postponed for another year?" Father smiled and waved him away, assuming his question had been meant in jest. But Uncle Ardi, without the slightest hint at humor, pressed on: "Really, Hakakian, why say it? Why not leave it at 'Love thy neighbor like thyself!' and call off the rest?" (Hakakian 2004, 51–52, 57)

In January 1979 Mohammad Reza Pahlavi left Iran following months of demonstrations and violence. In February the exiled leader of the opposition, Ayatollah Ruhollah Khomeini, returned to Iran and declared the victory of the Iranian Revolution, and hence the end of the Iranian monarchy. Shortly thereafter, the Iranian public voted in a referendum and supported the establishment of the Islamic Republic of Iran. What happened with the Jews of Iran during the 1979 revolution? Jews were part of the revolutionary movements too. Some of them took part because they opposed the Shah and belonged to student organizations, Tudeh, and other factions that did too. And some supported it just because they saw themselves as part of the Iranian masses revolting against an oppressive shah. In that sense, their assimilation project succeeded better than they could ever have imagined.

During the protests of the 1970s, while Tudeh Party activity had been outlawed, two Jewish activists, Haroun Parviz Yashayaei and Aziz Daneshrad, were jailed for anti-shah activity. After serving their time, they turned to political activity within the Jewish community (Menashri 1991, 360). Loyal to their leftist tendencies and religious identity, they gathered a dozen like-minded comrades and established the most significant Jewish organization in late 1970s Iran: Jamiʿah-i rawshanfikran-i kalimi-yi Iran (The Association of Jewish Iranian Intellectuals). In

1978 they challenged the old leadership of the community and won the community elections. They coordinated Jewish participation in the anti-shah demonstrations, one of which reportedly had over twelve thousand participants.

One of the glorious operations involved the Jewish charity hospital in Tehran (later named after its founder, Dr. Ruhollah Sapir). The hospital leadership had worked with Ayatollah Sayyed Mahmud Taliqani (Khomeini's representative in Iran before the revolution) to bring wounded protestors to Jewish hospitals to get treatment, as other state hospitals were required to report to the SAVAK (the secret police) on any wounded patient. This operation was made possible not just because of people who supported the revolution but also because of shah supporters who believed in the humanitarian mission of saving people. For its role, the hospital was recognized by the revolutionary government right after the revolution, and each president since then has made a symbolic monetary contribution to the hospital.

The 1979 revolution was a watershed moment for Iran and the Iranian Jews. The thriving community of about eighty to one hundred thousand Jews had experienced continual upward mobility, but in the aftermath of the revolution there was a massive wave of emigration from Iran, mostly to the United States and Israel. What started as a revolution hoping to establish an Iranian republic turned into an Islamic revolution eventually establishing an Islamic republic. Chaos and utopia dwelled together in Iran. The hopeful revolutionaries, among them many Jews, believed that they would be able to create a national project with solid institutions that would guarantee freedom and security to all and do away with the shah's tyranny, the SAVAK, and censorship. Little did they know that the revolution would merely lead to the perfection of the methods that existed before. Tens of thousands of Iranians started leaving the country. Many of them belonged to the upper middle class. Most Iranian Jews, especially in the capital, Tehran, were of the same socioeconomic status. Therefore, it is not surprising to see that so many of them went to the same places—namely, Los Angeles, which later came to be known as Tehrangeles because of the high concentration of Iranian immigrants. Some knew that they were leaving the country for good; others believed that it was temporary. Some returned for

visits or divided their time between two or more countries. As of 2020 the permanent Jewish population of Iran had dwindled to around fifteen to twenty thousand.[3]

Iranian Jews had a place in Mohammad Reza Pahlavi's vision of the Iranian nation-building project. He assigned them the role of bridging Iran and the West. (He designated the same role for Christian minorities. Interestingly, Zoroastrians served instead to connect contemporary Iran to its past.) Iranian Jews in this instance joined the Tudeh Party not to spite the shah but to allow themselves to be part of the greater Iranian society, which overwhelmingly supported Tudeh. They took the role of bridging Israel and Iran but refused to adopt either identity to the exclusion of the other. They felt gratitude to the shah but greater loyalty to their history, culture, language, and society. And at the end of the day the project succeeded: they saw themselves as both fully Jewish and fully Iranian.

Right after the revolution Iran went through a tumultuous period of political, social, and cultural chaos. The period of instability included the infamous hostage crisis at the American embassy, the Iran-Iraq War (1980–88), an economic crisis, international sanctions, the tensions with Israel and the United States, and, yes, religious intolerance, all of which facilitated the outgoing migration. It should be noted that Jews were not the primary victims of the Iranian regime. For various reasons, the Iranian regime became increasingly authoritarian and oppressive, and while there were both times of improvement and times of deterioration, the recognized religious minorities (Jews, Christians, and Zoroastrians) fared relatively well, something we cannot say about the large Baha'i community. The recognized minorities are represented in the Majlis and can operate their places of worship, religious schools, and community clubs and institutions. Some of them we get to see in this book.

The Iran-Iraq War was the formative experience of the new Islamic republic. During the war and in its aftermath Iran experienced devastation on a previously unknown scale. Hundreds of thousands of Iranians died on the front line and as civilians, and an entire generation grew up with the trauma of this long war and with neighbors and relatives who were wounded or had died. The Jewish community (which had shrunk significantly during the war) was no exception.

Iranian Jews joined the army as soldiers or professionals (in the medical fields, for example). In 2014 the Iranian government officially recognized the role of the Jewish community and unveiled a monument commemorating the Jewish fallen soldiers from the "Imposed War" (another name for the Iran-Iraq War). The unveiling of the monument provided the Jewish community with a much-needed acknowledgment of their participation in the national story.

After the revolution Iranian Jews faced multiple challenges. The victory of the Islamic revolution and the quickly escalating conflict with Israel put the Jewish community in a fragile position at times. While early on the leader of the revolution, Ayatollah Ruhollah Khomeini, distinguished between Judaism and Zionism by declaring the former a legitimate protected religion in Iran and the latter a political and ideological foe, Khomeini forced Iranian Jews to avoid even the appearance of any affinity with Israel or Zionism. As mentioned above, Jews are not barred from leaving the country, and despite the Western imagination seeing them perhaps in a similar position to that of Soviet Jews in the dark years of the Cold War or in a role similar to Sally Field's in *Not Without My Daughter*, the experience of Iranian Jews is remarkably different. They have been continuously represented by a Jewish deputy in the Majlis; they face some institutional and social discrimination and exclusionary religious practices but also have the means to appeal and get justice; they can worship freely and run their own affairs and institutions, and more. In short, the everyday life of Iranian Jews is far from being black or white.

Hope and despair coexist side by side for Iranians—Iranian Jews among them. Iranian Jews remember with trauma the execution of the Jewish leader and philanthropist Habib Elghanian in 1979 or the arrest of thirteen Jews from Shiraz in 1999 on false accusations of spying for Israel. They were hopeful about the political developments in Iran and legal reforms that corrected all sorts of discrimination against Jews in education (exempting Jewish students from attending school on Shabbat/Saturday) and amended inheritance laws that gave advantages to Muslim relatives of Jews, and at the same time they feared rapid escalation in local or international tensions that could pull them down or worsen the situation for them and the country.

The photographic journey that is laid before us provides the unique opportunity to see the Jews of Iran in the twenty-first century in a wide variety of situations, mostly those that remain hidden from an average Western point of view. Photographer Hassan Sarbakhshian spent two years traveling among the Jewish communities of Iran, joining them in their holidays, family gatherings, workplaces, shops, and travels and as they lived their Iranian lives. The photos reveal the much broader story. We see the beautiful synagogues and the cemeteries with gravestones in Polish that give us a glimpse of the story of this community in the 1940s during World War II, when hundreds of thousands of Polish refugees found shelter in Iran (Sternfeld 2018). We see their shops and community institutions and can imagine what these spaces looked like when the community was five or six times larger. The photos reveal one of the most beautiful and complicated untold stories of our time. It shows that behind those giant state and regional confrontations, there are people who live in the figurative and literal middle. They are Iranian by national definition, and they are Jews by religious affiliation. Full loyalty to their country is expected, and they are often suspected of loyalty to their ancestral homeland, Israel, which is at odds with their political and chosen homeland. The gray zone is the area this photographic journey illuminates.

—LIOR B. STERNFELD

How I Met Iranian Jews

Jews no longer live in my city, Tabriz. Before the revolution some one hundred thousand Jews lived in this country, but the victory of the 1979 revolution made many of them leave and made Iranians more curious and interested in hearing stories about Jews in Iran. During the shah's time, Israel and Iran had a close relationship with a full diplomatic representation and cooperation in myriad fields. Following the revolution, the once lively Israeli embassy on Kakh Street in Tehran was closed, and the building has served as the Palestinian embassy since then.

In 1999, twenty years after Iran's revolution, I covered my first assignment when thirteen Jews in Shiraz were accused of spying for Israel. Since then I have photographed demonstrations in which Iranians burned Israeli flags. Needless to say, the Islamic Republic of Iran does not recognize Israel anymore, and the two countries have become bitter enemies.

When Iran's former president Mahmoud Ahmadinejad denied the Holocaust during a conference in 2005 in Tehran, saying that the "Holocaust is a fictitious current idea" and that "the world without Israel will be safe," I knew I wanted to focus my work on the Iranian Jewish community. It was not easy, though, for an Iranian Muslim journalist to get close to their daily life in Iran. Then I met Parvaneh Vahidmanesh, who was researching the subject of Iranian Jews after the revolution. She suggested that I join her in documenting their lives. The photos in this book are the memories I have from a two-year project full of contrast and complexity, like Iranian society itself.

Every year, on the last Friday of the holy month of Ramadan, Iran celebrates Ruz-e Quds (Jerusalem Day). The leaders of the 1979 revolution declared these days would show solidarity and the significance of Jerusalem to Muslims and Iranians in particular. Members of the Iranian Jewish community regularly attend the Muslim Friday prayer ceremony to show their support for and solidarity with the Palestinian people. Later, when I attended the Jewish events in Tehran, I witnessed them praying to travel to Israel.

Iranian Jews travel to Susa to go on a pilgrimage to the shrine of the prophet Daniel. Muslims run the shrine of this Jewish prophet, and there are no Jewish or Hebrew signs on his shrine. Even on his stone, a Hadith of Imam Ali, the first Shiʾa imam, has been carved. When Jews attend the shrine, there is a women's section, and on that day the women's section is reserved for Jewish visitors—both men and women—for a couple of hours for the pilgrimage. The men's section of the shrine is for Muslim men.

On that trip I saw Jews reading Psalms and Muslims reading *Mafatih al-Jinan* (a popular devotional book). I also saw a Muslim woman wearing a hijab following Jews. She believed that these Jewish shrines satisfied her needs.

In another trip, to Hamedan, Jews stopped for their morning prayer in a Muslim establishment. I saw them praying toward Jerusalem under the picture of Imam Ali, where a couple of hours later Muslims would pray toward Mecca. When I visited the Jewish cemetery Beheshtieh in the Khavaran area in southeast of Tehran, I photographed a gravestone carved with a verse from the Qurʾan, Muslims' holy book, that is read when a person dies: "We belong to Allah and to Him we return." This suggests a fusion of the culture of Iranian Jews and Iran's Muslim culture, combining cultural elements in a way that sometimes makes it impossible to distinguish between Jews and Muslims in Iran.

In Mashhadiha Synagogue in Tehran I photographed the kosher slaughter of a cow, and I found out the ritual was very similar to the Muslim ritual slaughter of sheep or cows. The main differences are that for the meat to be kosher, it must be slaughtered toward Jerusalem, and a rabbi must be present. Also, the butcher must move the knife swiftly across the neck to kill the animal in a manner that minimizes any suffering or feeling of pain.

I photographed a young Iranian Jew who did not follow all the religious rules. Sometimes he had secretly eaten in Muslim restaurants. A young Jew in Shiraz told me he could not stop eating *chelo kebab* and *dizi*, two popular Iranian dishes.

In another trip to Shiraz, I visited a Jewish school. As the population diminished following Iran's 1979 revolution, Muslim students began using the school during weekdays, while Jewish students studying Hebrew and religious studies were there only on weekends. I photographed Jewish students playing and studying under a picture of Lebanese Hezbollah leader Sayyed Hassan Nasrallah. That same day I accompanied Shahrokh Paknahad, one of the thirteen Jewish men accused of spying for Israel in 1999, who had been freed after several years in prison. Together we visited a Jewish cemetery in Shiraz, where I took a picture of Iran's national flags flying over the grave of a Jewish soldier who died in the Iran-Iraq War (1980–88).

Photographing the Dr. Sapir Hospital and Charity Center in Tehran, the second-largest charity hospital in the world, was a great experience for me. This was the only place photographed for this book in which religion is not the top priority. I photographed Muslim babies

born at the hands of a Jewish doctor. I looked at a Jewish doctor whom Muslim mothers trusted to deliver their babies.

Although I had good experiences during my project, fear remained with me until I left Iran. When we delivered our book to Iran's Ministry of Culture and Islamic Guidance to get permission to publish in Iran, the Intelligence Ministry accused us of producing propaganda for Judaism. Interrogations and threats continued until my last day in Iran inside the black Peugeot of Iran's Intelligence Ministry, or in the office of foreign media in Iran's Cultural Ministry.

One agent, Mostafavi, accused us of getting support from Israel to complete this project. Finally, Iran's Cultural Ministry banned my press card, by order of the Intelligence Ministry. I was forced to leave Iran. A book we could have published in Iran was never published and remained in a dark room of Iran's censorship system.

Now a decade after we started this project, and with the help of Lior Sternfeld, I am happy to see our book finally published for a worldwide audience. Living in exile for almost nine years has taught me how hard it was for Iranians who left their country after the 1979 revolution. Many of them passed away in exile around the globe and have never had a chance to return to Iran.

—HASSAN SARBAKHSHIAN

My Story with Iranian Jews

We all have them: big family secrets that one day someone will uncover. My great-grandmother's story was one of these secrets that no one really wanted to talk about. Around 1900, a Jewish family living in the small city of Damavand, Iran, was forced to convert to Islam. They never let their children talk about their past, and the roots of their stories burrowed underground until a family member revealed the secret.

Since the day I learned our secret, I have sought to learn more about my ancestors. I entered the University of Tehran in 1998 in the field of history. In 2006, I asked my professor if, for my

MA thesis, I could work on Iranian Jews after the Islamic revolution. The professor rejected my proposal, saying it was "a very sensitive topic." I decided to work on this topic on my own.

On a sunny spring day, I entered a handicraft shop in Tehran to buy a gift for a friend. A star of David caught my eye. A few minutes later I met my best Jewish friends, who helped me discover more about my past. Peyman, Arash, and his father welcomed me with open arms and led me to find out more about Judaism in Iran.

Later in 2007, I met Hassan Sarbakhshian, a well-known Iranian photographer who was working at the time for the Associated Press news agency. We began to work together on a project to tell the story of Jewish lives in Iran.

For two years, Hassan had observed and covered more than forty locations, ceremonies, gatherings, and events for our photo essay book. He took well over five hundred photos. I wrote the story of each photo. As I spoke with people and told them of my interest in learning more about their lives in Iran, they warmly welcomed us and agreed to help us accomplish our project. We traveled with them to holy places, we ate Passover Seder dinner with them, and we celebrated Rosh Hashanah together. We danced with them on a bus going to Hamedan, and we prayed with them at the tomb of the prophet Daniel in Susa.

During one of our assignments, we met Parviz Minaee, a spirited organizer for the Jewish communities' trips and ceremonies who never said "no" to us. He opened locked doors no one had opened before. Sometimes it was really hard to get permission to cover a ceremony. The Iranian intelligence service never left us alone, especially since Hassan worked for an American news agency. Even some officials at Jewish associations could not totally trust us because of pressure from the Islamic government.

We nearly ended this project several times during this journey, but Farhad Aframian, the head of the cultural committee of Tehran's Jewish association, convinced his colleagues to let us go forward. "They have collected and saved our history, which would otherwise be forgotten. We should support them," he said.

We finished the book in mid-2008 and sent it to the Ministry of Culture to get permission to publish, but the Iranian intelligence service called both of us and claimed that the book was propaganda for Israel. We would never be able to publish the book in Iran.

In 2009, following the fraudulent presidential elections, we left Iran for the United States. Forced emigration never gave us an opportunity to publish this photographic journey in Iran. Another dream of making a movie about Iranian Jews was never realized. But we never gave up; even if only a part of this project could be seen by people, it could make a difference.

I know many Iranian Jews in Israel, the United States, and Europe may imagine their relatives in this collection. It will remind them of synagogues where they prayed every Shabbat, and they are likely to miss them when they see this book. Many of them will wipe their tears when they turn the pages, just as we do. And maybe in the near future we will all gather again in Iran.

—PARVANEH VAHIDMANESH

Notes

1. See a recent interview with Iran's chief rabbi, estimating the number of Jews living in the country in 2020 at twenty to twenty-five thousand (Goldman 2020).

2. Alliance Israélite Universelle was a French Jewish network of schools in the Middle East and North Africa aimed at "civilizing" Middle Eastern Jews and elevating their social status.

3. See this interview with Chief Rabbi of Iran Yehuda Garami in 2020: https://www.al-monitor.com/pulse/originals/2020/06/israel-iran-qasem-soleimani-jewish-community-coronavirus.html.

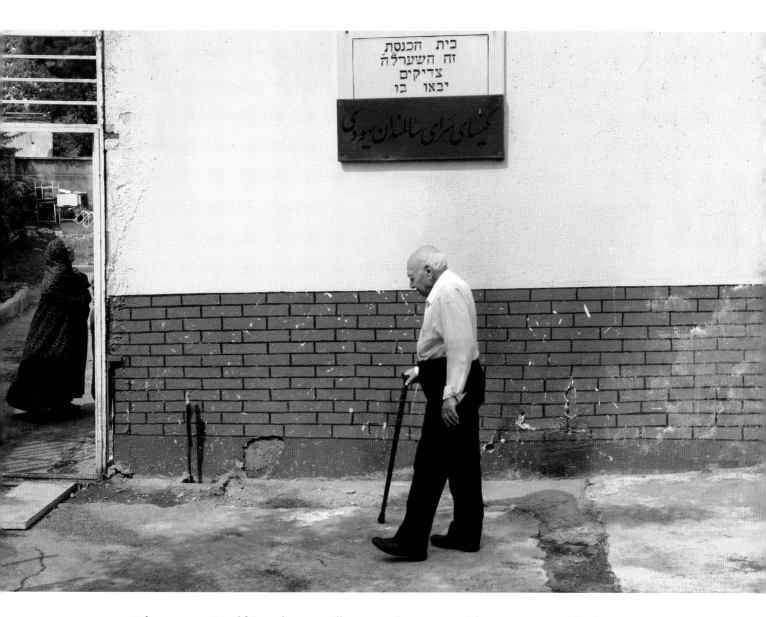

FIGURE 3 Tehran, 2007. An old Jewish man walks across the entrance. The sign written in both Persian and Hebrew welcomes the visitors to the synagogue in this compound.

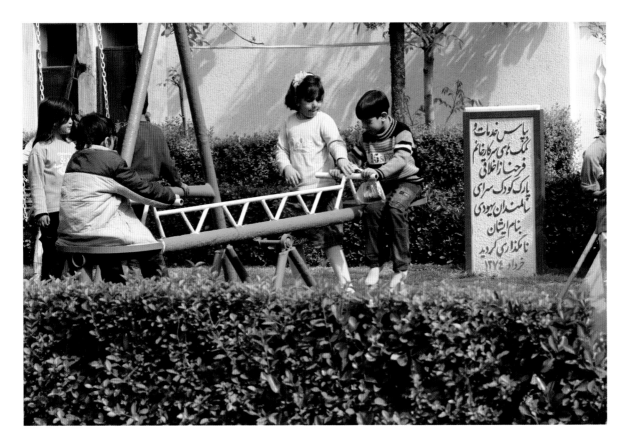

FIGURE 4 Tehran, 2008. Khaneh-ye Salman-dan has a vast park within its limits as well. A playground inside the park was built with the financial aid of Farahnaz Akhlaghi, an Iranian Jew. Here, a group of kindergarten children visits Khaneh-ye Salmandan as part of an annual school program that brings children to visit this center two to three times a year.

FIGURE 5 Tehran, 2008. Kindergarten children eat their snacks in Khaneh-ye Salmandan's park.

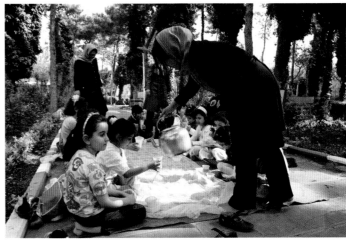

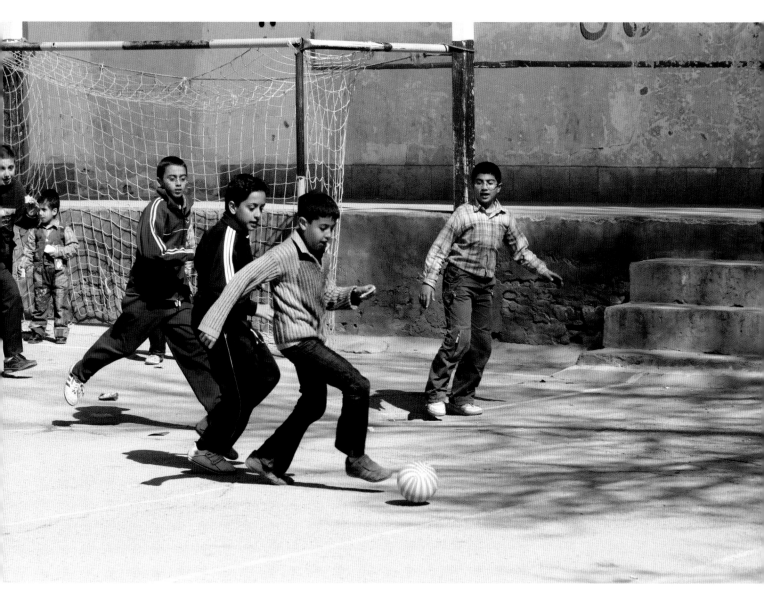

FIGURE 6 Shiraz, 2008. At noontime on Fridays, Jewish boys play soccer in Hebrew school. The game is a great chance for them to meet other Jewish kids their age. One ten-year-old said he waited all week to go to the Friday Hebrew school and meet his friends.

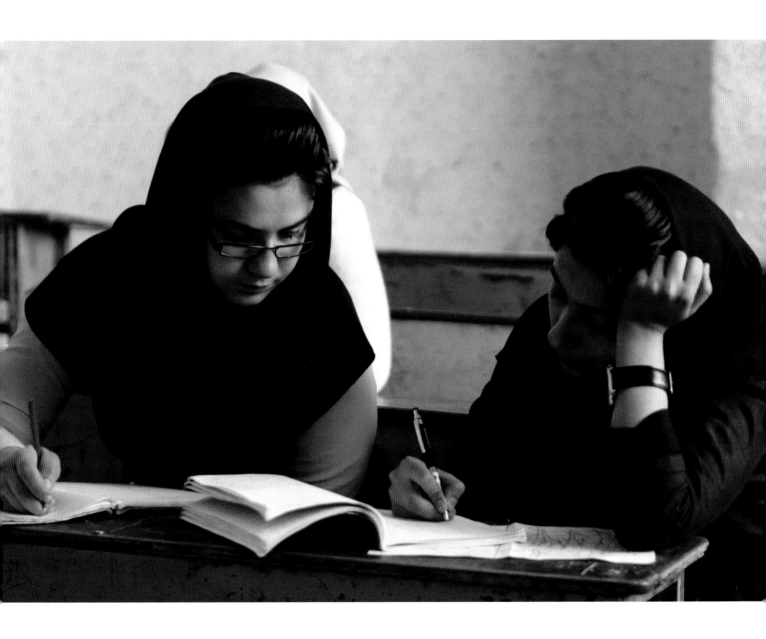

FIGURE 7 Shiraz, 2008. Two Jewish girls do their Hebrew homework in the religious school in Shiraz. Before the 1979 revolution, there were many Jewish schools active all over the country. However, due to mass emigration from Iran, many of the schools closed. Kowsar School, previously a Jewish school, is now used by Iranians of various religions. Today, Shirazi Jews usually study at public Muslim schools, where they are not required to attend religious classes. They use the school on Friday, when it is unoccupied, to study Hebrew and Jewish religious studies.

One student attends the Qurʾan class to learn more about Islam. She described how Jewish students do not have the weekend most students have because they must attend classes on Friday and Saturday (the regular weekend in Iran is Thursday and Friday). This has since changed. In 2015 President Rouhani's administration recognized Shabbat (Saturday) as a holy day and exempted Jewish students from attending school. This change came after a long battle by the Jewish leadership in the country.

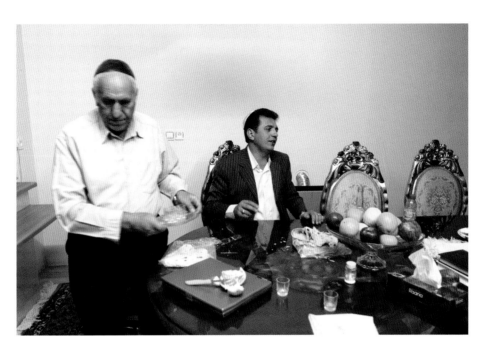

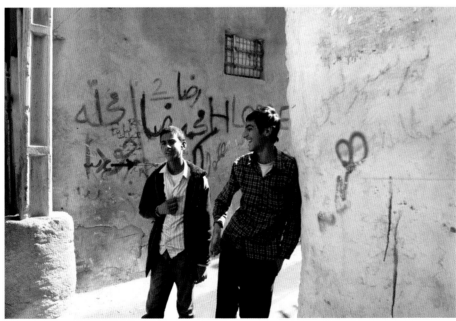

FIGURE 8 Shiraz, 2008. Ghodratallah Haim, left, from an elite Jewish family in Shiraz. In a previous visit to Shiraz with my American Jewish friend, we serendipitously met a Jewish family in the bazaar. They invited us to their picnic and shared stories with us on the history of Judaism in Iran.

When I visited a second time, they kindly invited us to their house. Mr. Levi Haim (right), a highly trusted man among the Iranian Jews, told us that Soleiman Haim, a Jewish scholar who wrote one of the most important dictionaries (which made him a household name in Iran), was his uncle.

FIGURE 9 Shiraz, 2008. Two young men seen in a Jewish neighborhood in Shiraz.

For decades within Shiraz, which has the second-largest Jewish population in Iran, there were two rival neighborhoods (*mahalleh*, in Persian). After Zand Street was constructed, it divided the Jewish neighborhood into two separate mahallehs, each with its own facilities, bathhouse, synagogues, and rabbis. One of them gained the name Zir-e Tagh (see Sarshar 2002, 104).

Most of the Jews in Shiraz were originally tradesmen and held most other occupations. Today, most Jews in Shiraz sell jewelry, fabric, vegetables, clothes, shoes, and more. Here, two young Iranian Jews are seen in a mahalleh. In the background, the words *Mahalleh-ye Joodha* is written, translating to "the neighborhood of Jews." *Jood* (or *Johood*) is a derogatory term for Jews.

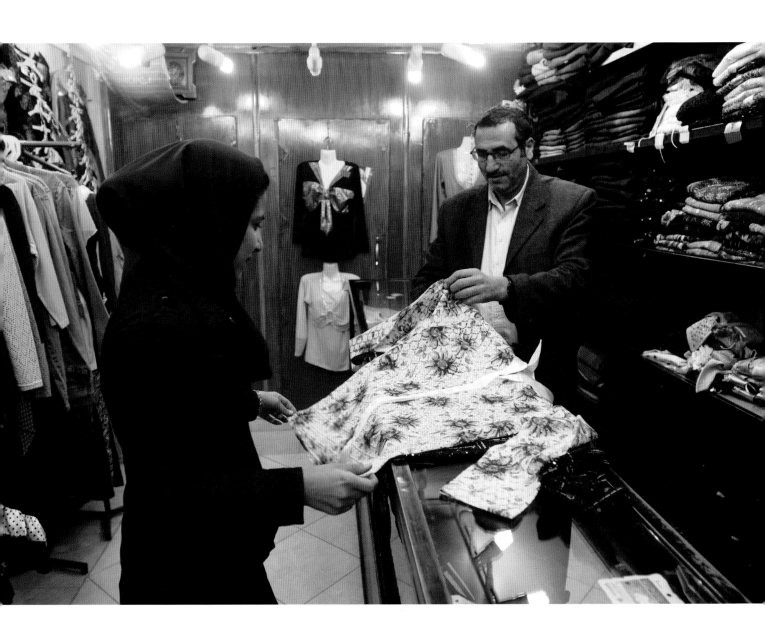

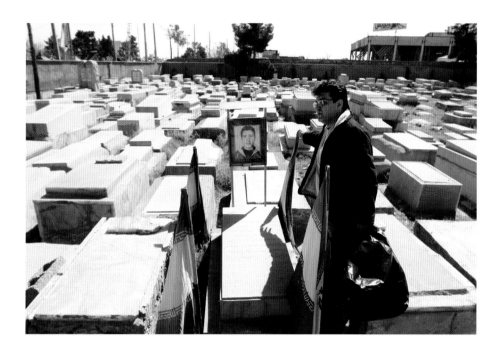

FIGURE 10 | OPPOSITE Shiraz, 2008. A Jewish man sells clothes to a Muslim woman at the bazaar. The shop, located in a dark passageway, sees many Iranian customers, 85 percent of whom are Muslim, according to the shop's owner. Throughout Iranian history, Muslims bought all but bread and meat from Jewish-owned shops. Today, Iranian Jews are known for selling musical instruments, jewelry, and antiques.

FIGURE 11 Shiraz, 2008. Shahrokh Paknahad, one of thirteen Iranian Jews who were accused of spying for Israel in 1999. He was later released after several years in prison. In this photo, he visits the grave of a Jewish martyr killed during the Iran-Iraq War (1980–88) in Shiraz's Jewish cemetery.

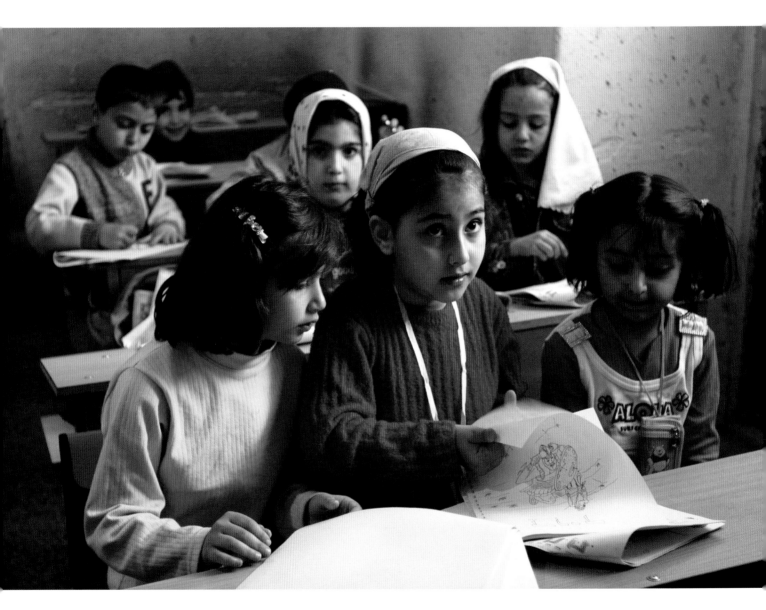

FIGURES 12 AND 13 Shiraz, 2008. Shirazi Jews learning Hebrew in a vacant public school on a Friday afternoon.

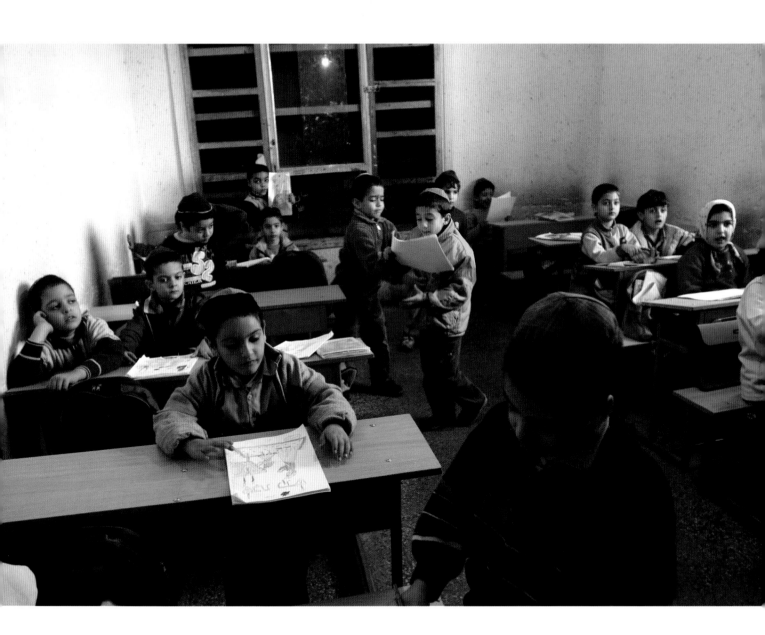

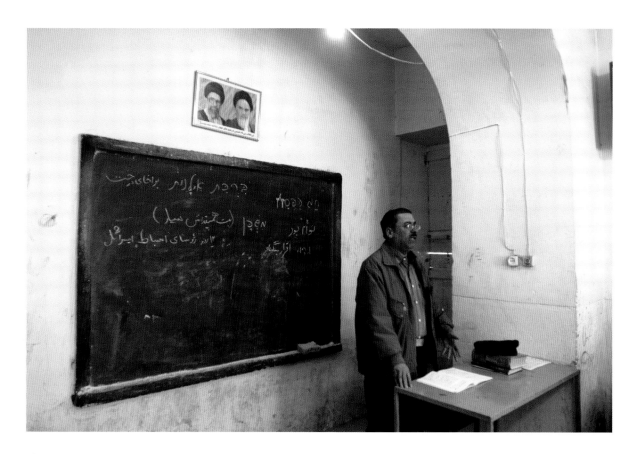

FIGURE 14 | OPPOSITE Shiraz, 2008. Under the picture of the late founder of the Islamic Republic of Iran, Ayatollah Ruhollah Khomeini, and the Supreme Leader, Ayatollah Ali Khamenei, a Jewish teacher explains the ritual of the tefillin at his religious guidance class at a public school in Shiraz. Tefillin, also called phylacteries, are a set of small black leather boxes containing scrolls of parchment inscribed with verses from the Torah that observant Jews are required to put on every weekday (but not on Shabbat).

FIGURE 15 Shiraz, 2008. A member of the Iranian Jewish community teaching Jewish history to his students in Shiraz. In this photo, the teacher explains several of the blessings, including the one for the trees, which is recited during the whole Hebrew month of Nissan and in which Jews thank God for the beauty of the world and the fruits.

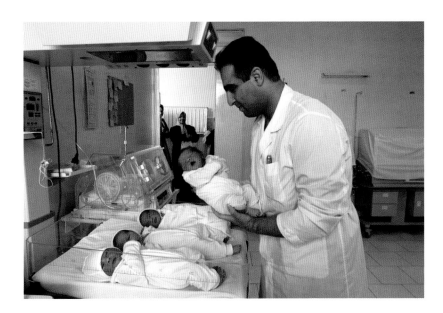

FIGURE 16 Tehran, 2007. A Jewish physician, Dr. Shariar Azari, visits newborn Muslim children at the Dr. Sapir Hospital and Charity Center, which is owned by the Iranian Jewish community.

The story of this hospital is interwoven with that of the Jewish communities of Iran generally. It was established in 1941 by Dr. Ruhollah Sapir, a Jewish physician, who worked at another Tehran hospital and witnessed a Jewish patient being mistreated because of her Jewish faith. He established this hospital at the Mullah Hanina Synagogue and called it Kanoon-e Kheir Khah; it was founded to provide good care for anyone, regardless of their faith or status. In the 1940s the hospital treated Polish refugees, many of whom had typhus, which Dr. Sapir himself contracted and died from in 1943. Later the hospital's name was changed to Cyrus the Great (Koroush-e Kabir), and it became instrumental in establishing one of the prominent nursing schools in Iran. During the revolution of 1979 it sheltered and treated wounded revolutionaries, adhering to the famed Jewish mitzvah (one of the 613 biblical commandments) "Thou shalt love thy neighbor as thyself" (see Sternfeld 2014). After the revolution, the establishment was renamed once again, this time to bear the name of the founder, Dr. Ruhollah Sapir. The hospital, which Dr. Sapir started with only a desk and a chair, became a central and important feature of the Jewish community well into the twenty-first century.

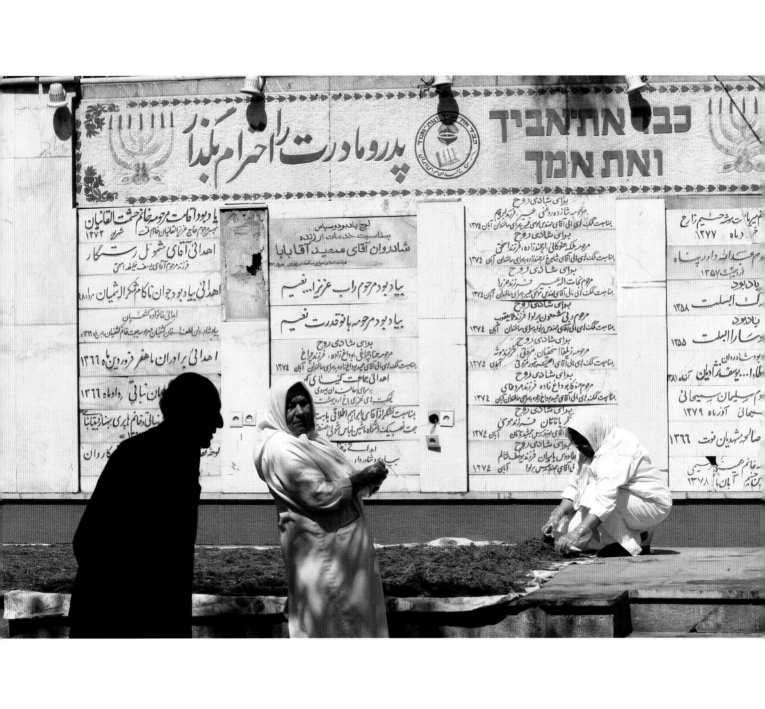

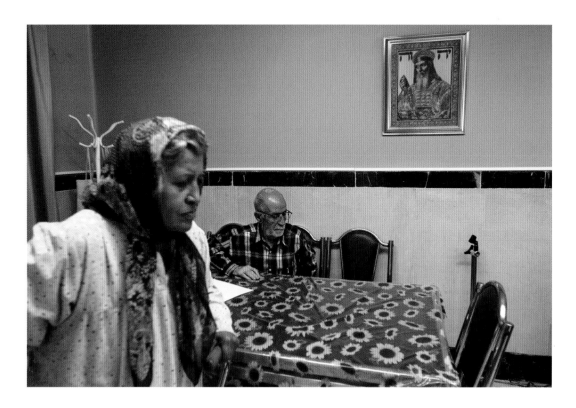

FIGURE 2 Tehran, 2007. In 1963, the Jewish community decided to establish Khaneh-ye Salmandan as a retirement home for old and disabled Jews in Iran. This 2,228-square-meter center is located in the heart of Tehran. It has more than twenty rooms on its two floors, as well as a vast park, a synagogue, a slaughterhouse, a gym, and a physiotherapy center. The center faced challenges following the Islamic revolution in 1979, after many families who helped support this establishment left Iran. For various reasons, a significant number of elders stayed behind in Khaneh-ye Salmandan while their families migrated elsewhere. Although there were welfare organizations in place to help those living in the center, it was not enough, so the Jewish community sought aid from its wealthier members. Now, fortunately, there are experienced staff on hand who work in three shifts at this center. Figure 2 shows two residents of Khaneh-ye Salmandan.

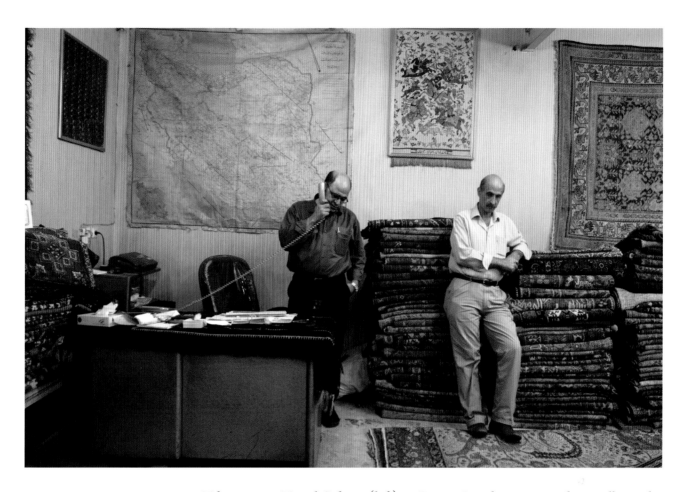

FIGURE 17 Tehran, 2008. Hertzl Gidaian (left), an Iranian Jewish carpet merchant, talks on the phone in his shop in the Tehran Grand Bazaar. Gidaian is one of the most famous and trusted Iranian Jews working at the bazaar, where he owns a large shop. He loves Iran and believes this country is his land. Like Gidaian, many members of the community sell carpets, handcrafted goods, and antiques.

An urban legend in Iran has it that a long time ago, Jews were moving from city to city to buy antiques, carpets, and jewelry, as it was once difficult for them to own shops. Soon after this began, according to the story, the Jewish community became the best collectors of Persian ancient art.

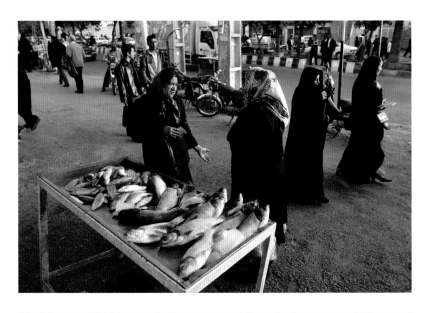

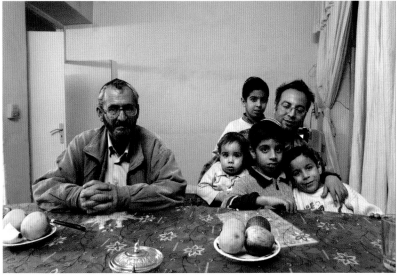

FIGURE 18 Dezful, 2008. Jewish women talk in the local market.

FIGURE 19 Yazd, 2008. Haroun (left) talks about his family who moved to Israel.

FIGURE 20 | OPPOSITE Dezful, 2008. During a trip to the shrine of the prophet Daniel in Susa, Tehrani Jews stop in Dezful to buy gifts and rest.

Business and Everyday Life

FIGURE 1 Tehran, 2007. On a summer day, around Passover, two personnel from the retirement home Khaneh-ye Salmandan (House of Elders) put vegetables on the ground to dry them for future consumption. Iranians use a lot of dried herbs like parsley, dill, and coriander for cooked food. On the wall behind the two staff members, it is written "Honor thy father and thy mother" in both Persian and Hebrew. The wall also lists the names of charitable organizations and donors.

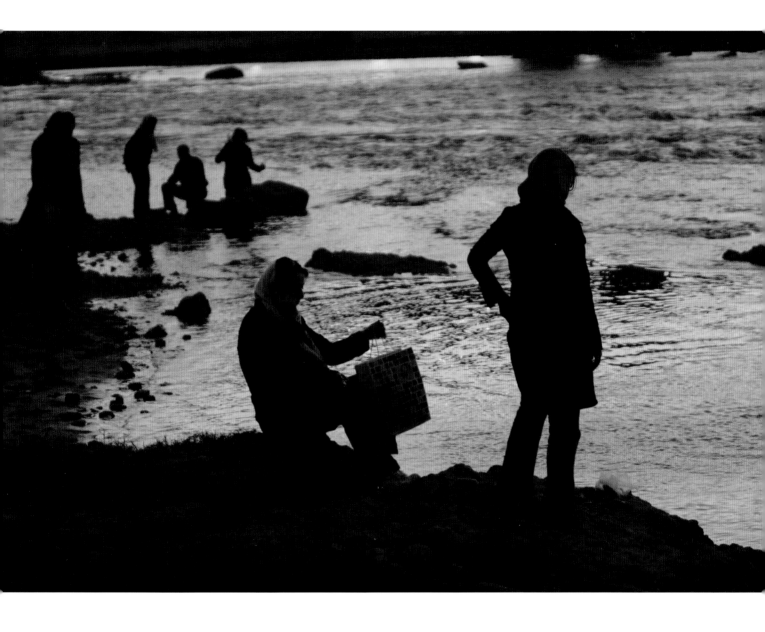

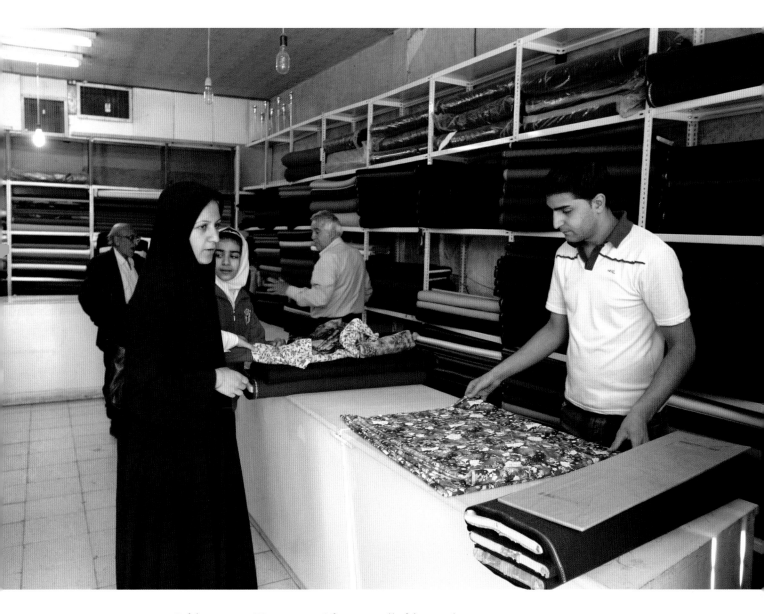

FIGURE 21 Isfahan, 2007. Homayoun Aframian sells fabric in his store.

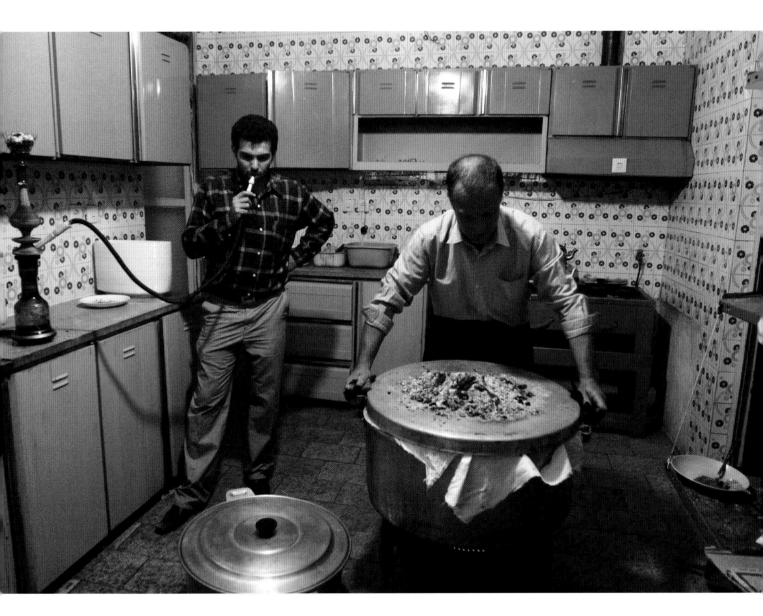

FIGURE 22 Isfahan, 2007. A Jewish chef cooks at the only kosher restaurant in Isfahan. In this photo, we see the preparation for the reopening of this establishment after having been shut down for a while.

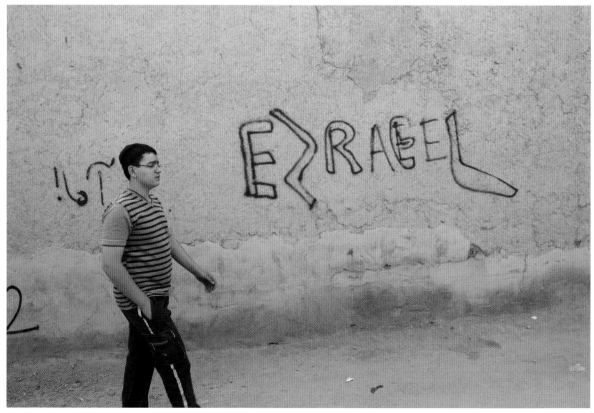

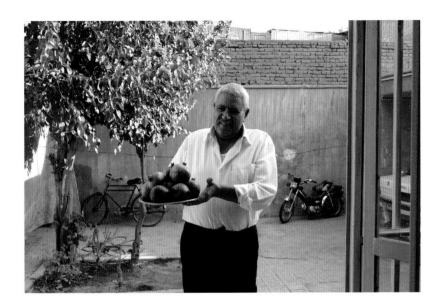

FIGURE 23 | OPPOSITE Isfahan, 2007. Iranian Jewish men play the violin and the *tombak* (a traditional drum) at one of the last two kosher restaurants in Isfahan shortly before it shut down.

FIGURE 24 | OPPOSITE Kerman, 2007. A young Jewish man passes a Jewish neighborhood in Kerman, southeast Iran. Ezraeel, today a political pun, is the angel of death in the Abrahamic religions. The similarity in pronunciation between Ezraeel and Israel allows opponents of Israel within Iran to display their feelings toward Israel while also comparing it to the death angel (see Al-e Ahmad 2017).

FIGURE 25 Kerman, 2007. A Jew welcomes his guests at home in Kerman, 600 miles southeast of Tehran. At its peak, around 1900, Kerman had a Jewish population of about two thousand. By the mid-twentieth century the Jewish population was around one thousand, and in the 1960s it dwindled to around five hundred. The Kerman community maintained the Jewish schools, synagogues, and a Zionist association throughout its existence. In the second half of the twentieth century, with many Iranian Jews moving to the big cities and emigrating to Israel, Kerman saw its Jewish community shrinking drastically.

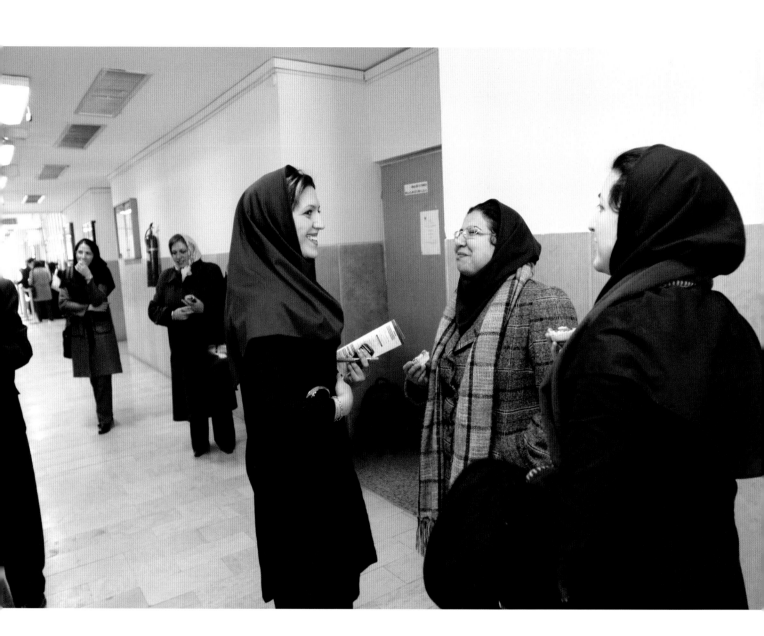

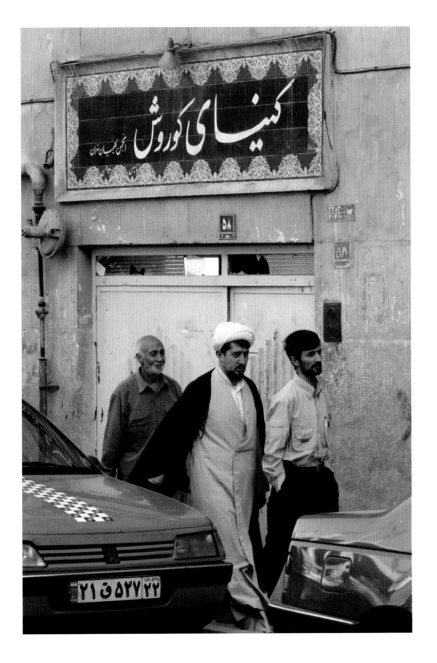

FIGURE 26 | OPPOSITE Tehran, 2008. Sepideh Saketkhu (left), a Jewish graduate student, talks with her friend at Tehran Azad University.

FIGURE 27 Tehran, 2008. Iranian Muslims, alongside a cleric, walk past the Cyrus (*Koroush*, in Persian) Synagogue in Tehran.

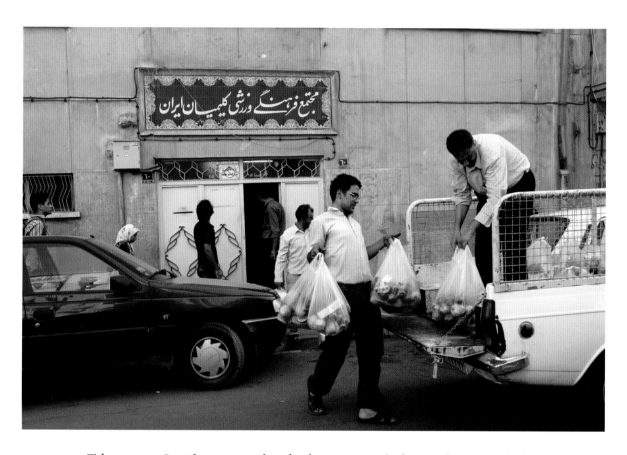

FIGURE 28 Tehran, 2008. Jewish men providing food to poor Jews before Rosh Hashanah, the Jewish New Year outside the "Cultural and Sports Community of Iranian Jews."

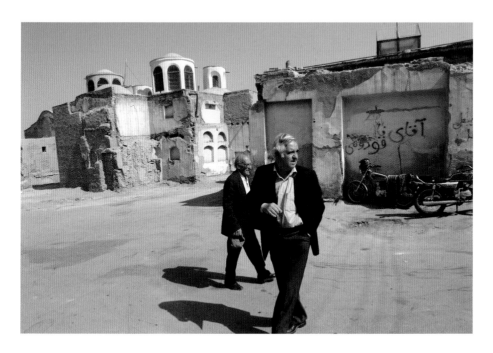

FIGURE 29 Isfahan, 2007. Homayoun Aframian walks in the Joobareh neighborhood in Isfahan, previously deemed a Jewish mahalleh. Nowadays both Jews and Muslims live here.

Tehran, Shiraz, Isfahan, and Yazd all have their own Jewish communities with their own establishments founded to help mediate intracommunal matters of representation vis-à-vis the authorities. Their centers hold Hebrew classes for youths, provide kosher food, hold religious trips to other cities, deal with life events and burial issues, and publish newsletters and religious texts, among other duties.

The majority of the Jewish community currently resides in Tehran, where they communicate with the government regarding parliamentary candidates and social benefits. Israel remains an important topic of discussion in Iran, as the Jewish community has to continuously show its separation and distance from the State of Israel.

FIGURE 30 Isfahan, 2007. Homayoun Aframian and another Jewish man from Isfahan talk with a Muslim woman in a previously Jewish quarter.

FIGURE 31 Tehran, 2008. A group of Jewish community members (at rear) attend the annual celebration of the Islamic Republic of Iran in 2008. This celebration marks the thirtieth anniversary of Iran's 1979 revolution according to the Persian calendar (from 1357 to 1387).

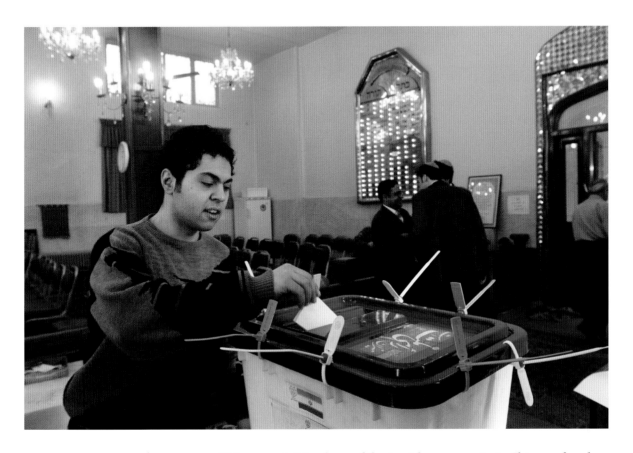

FIGURE 32 | OPPOSITE Shiraz, 2008. Members of the Jewish community in Shiraz, a few days after the anniversary of the death of Ayatollah Ruhollah Khomeini. Shiraz has the second-largest population of Jews in Iran. The community center in this picture was built in 1972 and includes women's, youth, and student committees.

FIGURE 33 Tehran, 2008. A young Jew votes in parliamentary elections. Ever since the constitutional revolution of 1906–11, Iranian Jews have held a seat in the Iranian parliament (with the exception of the first Majlis).

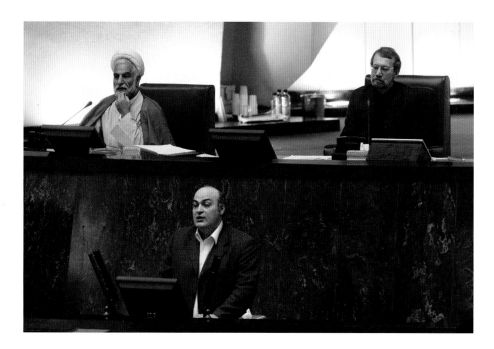

FIGURE 34 Tehran, 2008. Siamak Moreh Sedegh speaks at Iran's Islamic consultative assembly. The speaker of parliament, Ali Larijani, is sitting in the top right of this photo.

FIGURE 35 | OPPOSITE Tehran, 2008. Siamak Moreh Sedegh, the Jewish deputy of parliament, met Mahmoud Ahmadinejad at Iran's Islamic consultative assembly in 2008. Dr. Moreh Sedegh served as the Jewish representative in parliament from 2008 to 2020 and is also the director of the Tehran Jewish Committee and the Dr. Sapir Hospital and Charity Center in Tehran, where he practiced as a physician. He often speaks at parliamentary meetings and attempts to show the Iranian Jewish community's independence from Israel.

The constitution of the Islamic Republic of Iran says that Iranian Jews can elect one representative for parliament. This representative tries to bring Jewish community issues to the table. To elect this representative, Jews always vote inside synagogues. Above, Iranian Jews vote inside the Yousef Abad Synagogue.

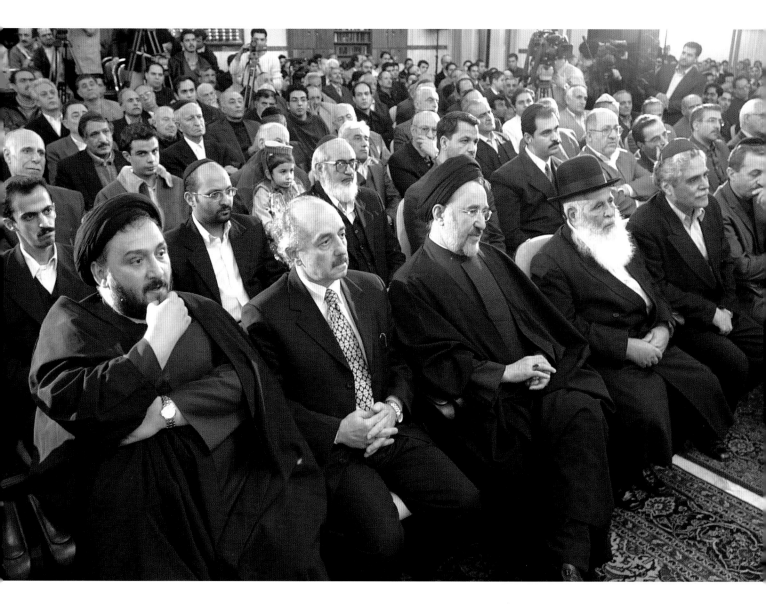

FIGURE 36 Tehran, 2004. Mohammad Ali Abtahi, Dr. Leon Davidian (the Armenian deputy in the sixth Majlis), former president of Iran Mohammad Khatami (1997–2005), Chief Rabbi Yusef Hamadani Cohen, Haroun Yashayaei, and former member of the Iranian Jewish Parliament Morris Motamed attend an event at the Yousef Abad Synagogue.

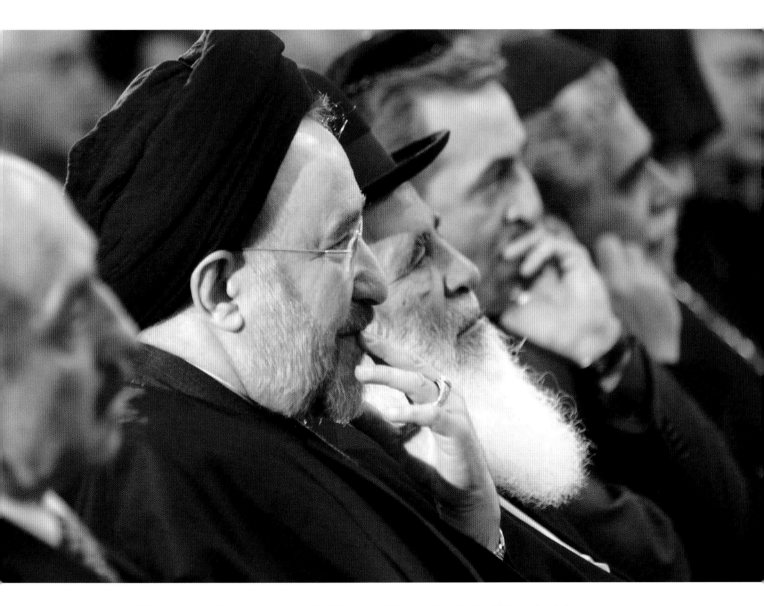

FIGURE 37 Tehran, 2004. Former president Mohammad Khatami visits the Tehran Jewish community at the Yousef Abad Synagogue.

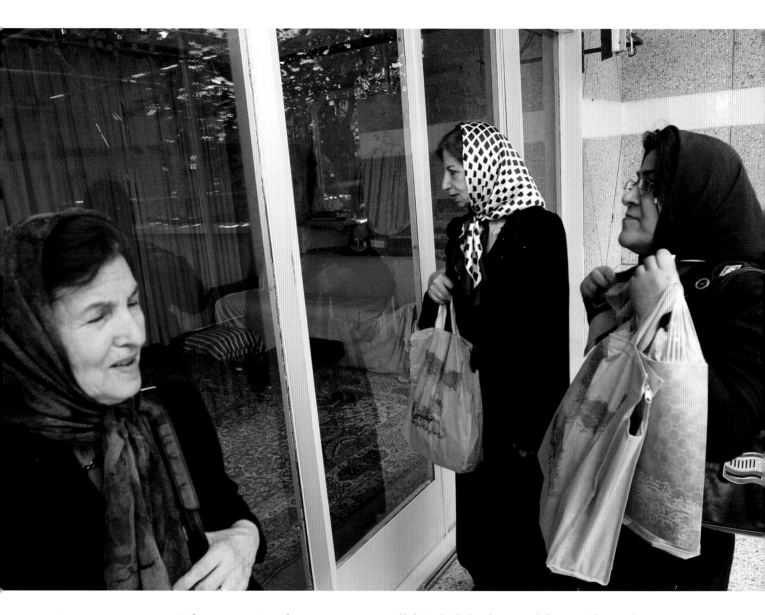

FIGURE 38 Tehran, 2008. Jewish women visit Ayatollah Ruhollah Khomeini's house. This is also a way to show loyalty to the Iranian republic, especially in the context of the rising tensions between Israel and Iran and the occasional accusation of double loyalties.

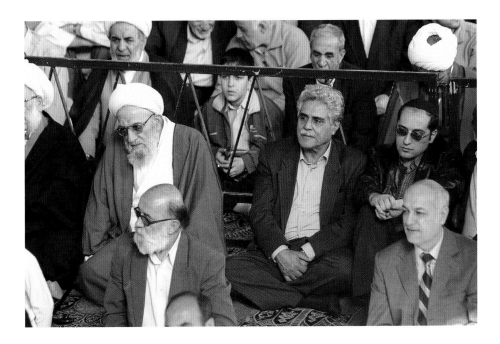

FIGURE 39 Tehran, 2004. Haroun Yashayaei (middle), former head of the Jewish community in Iran, attends Muslim Friday prayer to show solidarity with the Palestinians. Iran's former interior minister Ayatollah Mohammad Reza Mahdavi Kani (left) is seen alongside Yashayaei.

Jerusalem is important to Muslims as the site where the Prophet Muhammad began his journey to heaven. In 1979, the leader of the Islamic revolution, Ayatollah Ruhollah Khomeini, declared the last Friday of the Muslim holy month of Ramadan as Ruz-e Quds, "Jerusalem Day." This is a day of protest, with rallies across Iran showing the importance of Jerusalem to Muslims, protesting Israel's control over Jerusalem, and demonstrating support for the Palestinian cause.

Since the early days of the Islamic Republic, Jewish community members have partaken in the Friday prayer ceremony with Muslims. The Jewish community also participates in the Ruz-e Quds demonstrations against Israel.

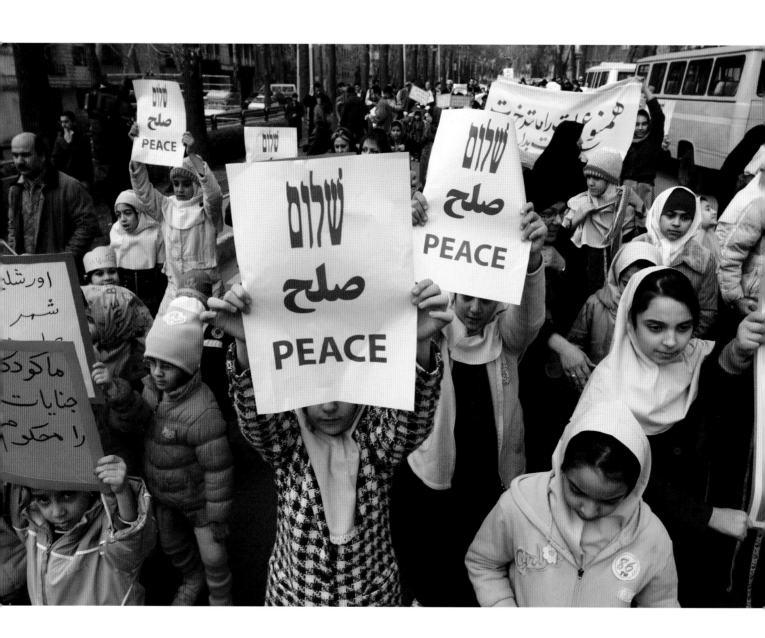

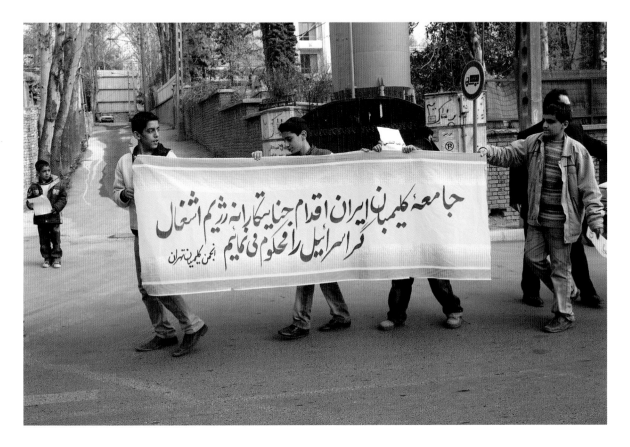

FIGURE 40 | OPPOSITE Tehran, 2008. Children in the Jewish community demonstrate for peace.

FIGURE 41 Tehran, 2008. A group of Jewish youths carries a banner that condemns Israel's attacks against Palestinians as they attend an anti-Israel demonstration. The banner reads, in Persian, "Iranian Jewish society condemns the criminal acts of the Israeli authorities."

FIGURE 42 Shiraz, 2000. A family member of an Iranian Jew who was accused of spying for Israel.

In 1999, the Iranian intelligence service arrested thirteen members of Shiraz's Jewish community for allegedly spying for Israel. Among them were a university professor, merchants, teachers, a butcher, and a rabbi. Following a successful global campaign against what were perceived to be false accusations, most of them were sentenced to short prison terms, and all were released within a few years.

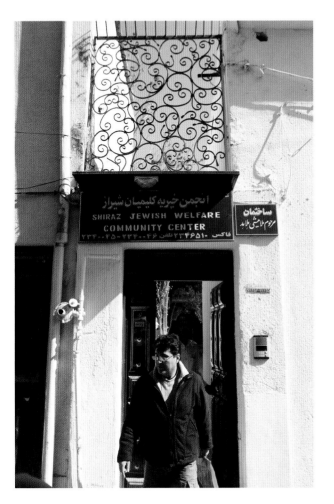

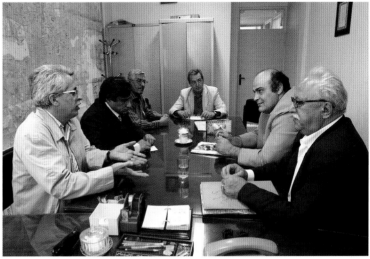

FIGURE 43| LEFT Shiraz, 2008. The Shiraz Jewish Welfare Community Center .

FIGURE 44 Tehran, 2007. Feyzollah Saketkhu, Siamak Moreh Sedegh, Morris Motamed, and other Jewish community members attend an association board meeting.

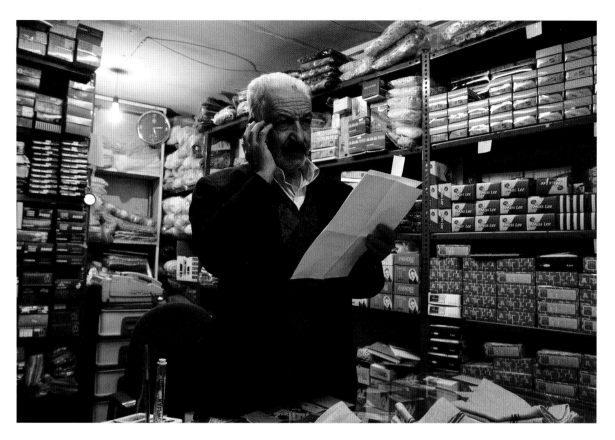

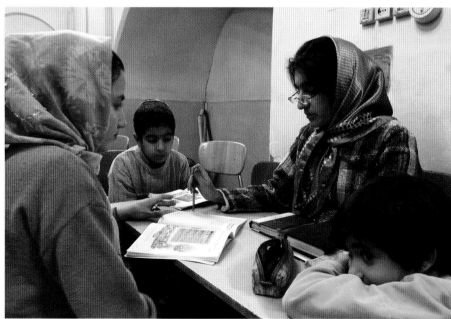

FIGURE 45 | OPPOSITE Yazd, 2008. A Jewish businessman in his shop. Speaking on the phone with an Iranian official from the Ministry of Culture, he is awaiting permission to allow the photographing of a synagogue in Yazd.

FIGURE 46 | OPPOSITE Yazd, 2008. A twenty-year-old woman teaches Hebrew to children.

FIGURE 47 Yazd, 2008. A group of Jewish pilgrims.

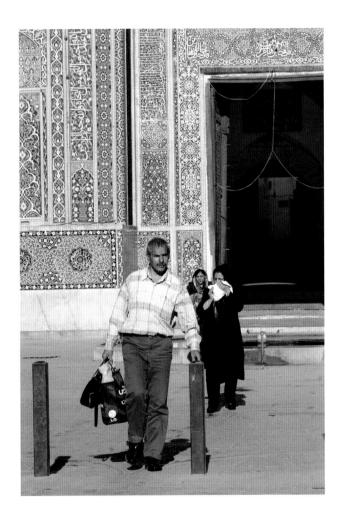

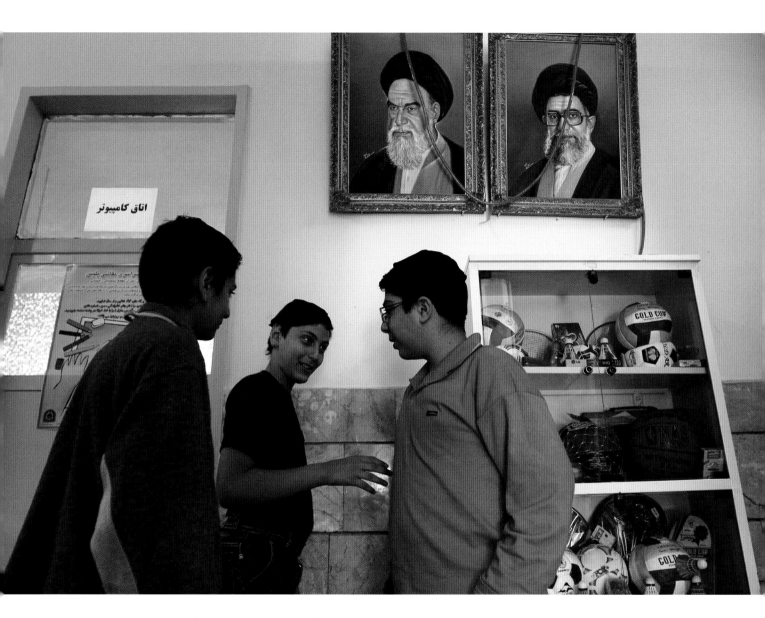

FIGURE 48 Tehran, 2007. A group of Jewish students at the Musa Bin Emran School. Ayatollah Ruhollah Khomeini and Ayatollah Ali Khamenei are pictured above the students.

Religious Life and Rituals

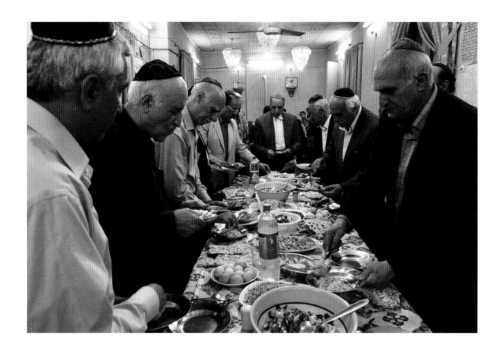

FIGURE 49 Tehran, 2008. Jews celebrate Purim. The holiday recalls the threat of extermination to the Jewish community in Ancient Iran at the hands of Haman, a minister to King Ahasuerus (Xerxes). Every year, a month before Passover, the Jewish people celebrate the Feast of Purim. This feast originates from the book of Esther in the Bible.

FIGURE 50 | OPPOSITE Tehran, 2008. Purim's traditions include wearing masks and costumes and behaving foolishly in celebration of the Jews' eventual victory. In this photo, two partici-pants perform the story of Purim at the Mashhadiha Synagogue in the south of Tehran.

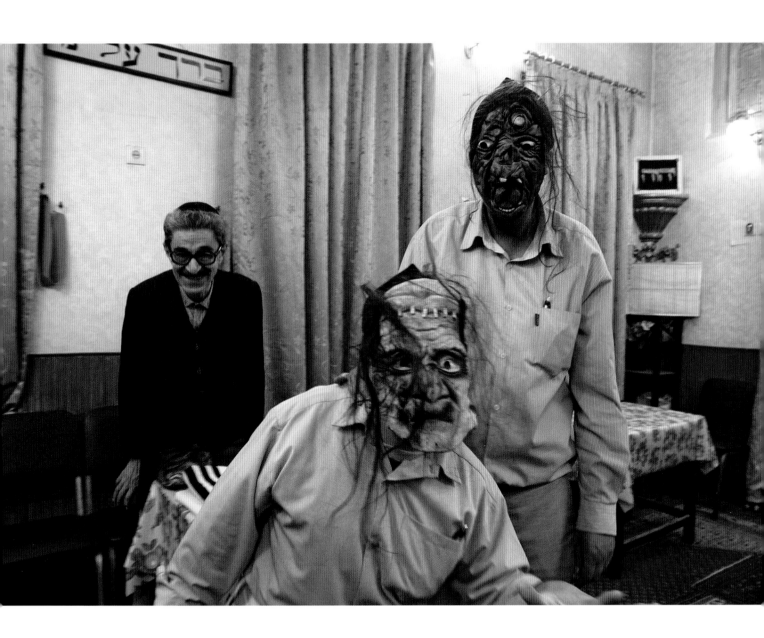

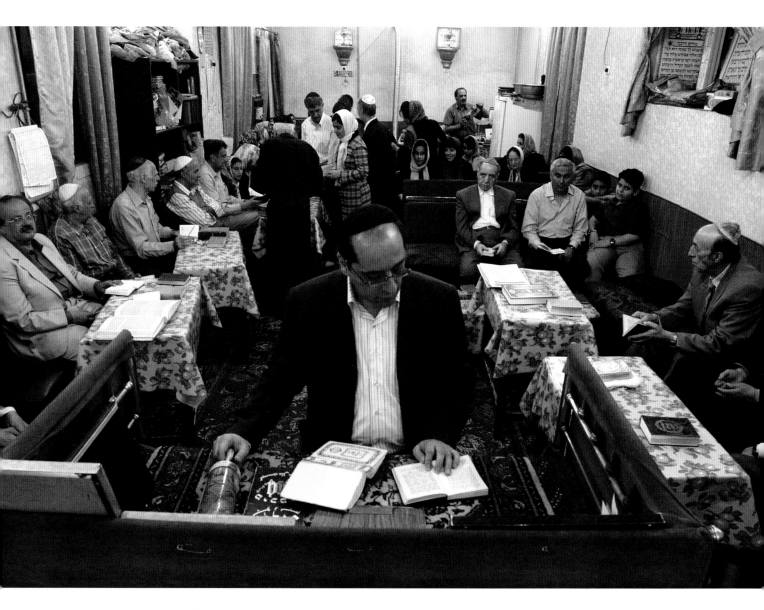

FIGURE 51 Tehran, 2008. Arash Abaei reads the scroll of Esther during the Purim celebration at the Mashhadiha Synagogue.

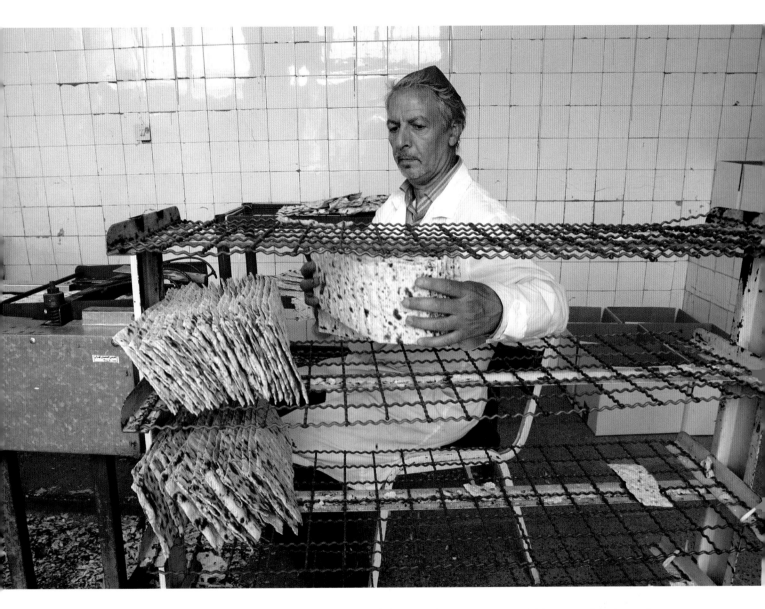

FIGURE 52 Tehran, 2008. Parviz Minaee, a member of the Jewish community in Tehran, makes matzah, an unleavened bread that Jews eat during the Passover holiday.

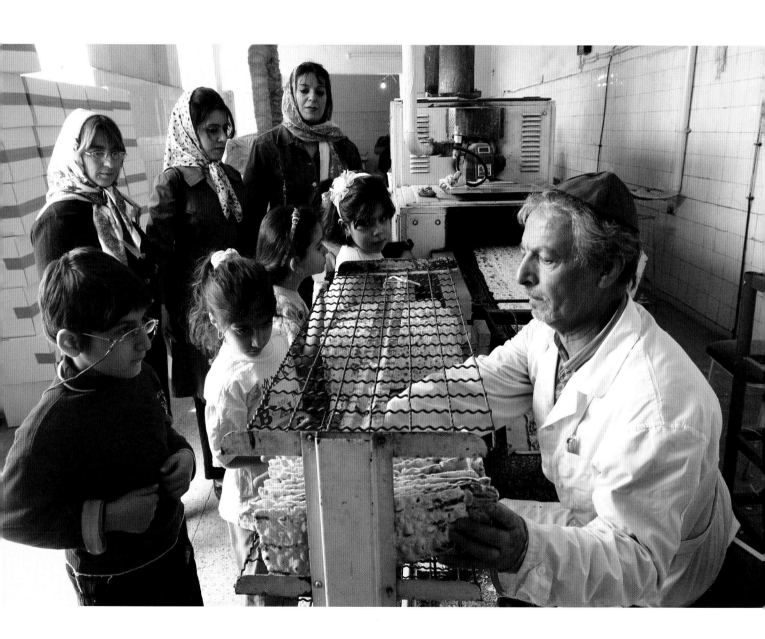

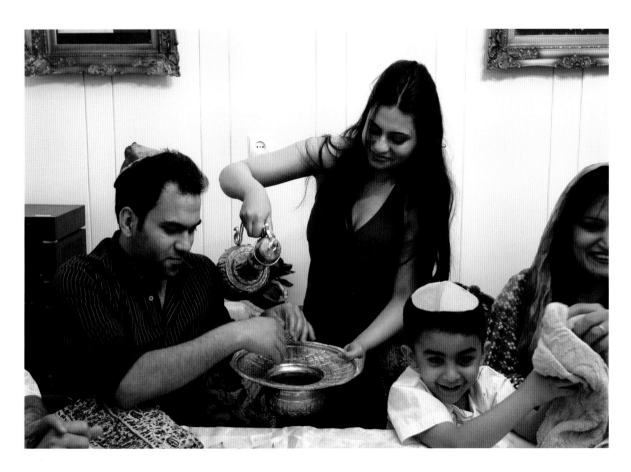

FIGURE 53 | OPPOSITE Tehran, 2008. Parviz Minaee shows children how to make matzah.

FIGURE 54 Tehran, 2008. The Aframian family gathers for the traditional Passover ceremony.

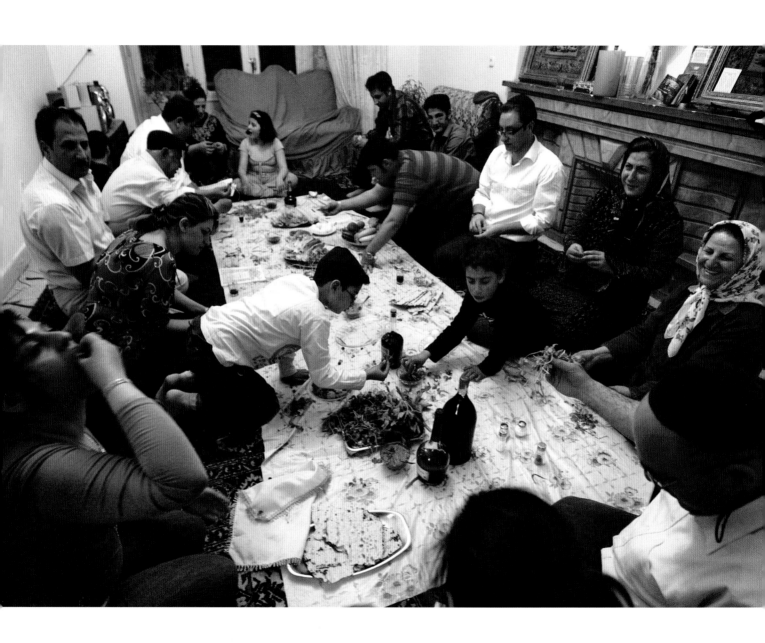

FIGURE 55 Tehran, 2009. Passover is the spring holiday that commemorates the exodus of the ancient Israelites from Egypt and the escape from slavery to freedom. Every year Jews tell the story of their slavery and redemption. The Talmud says, "In each and every generation a person is obliged to regard himself as if he had come out of Egypt," and the Torah says, "You shall tell your son that day, 'It is on account of what God did for me when I came out of Egypt.'" The Passover Seder is about this tradition of retelling the story and thinking about those times of hardship and redemption.

In this photo, Hertzl Gidaian's family celebrates Passover in their house in Tehran. They sit around a traditional tablecloth on the carpet to eat Passover dinner, beginning their meal with vegetables and lettuce.

FIGURE 56 Tehran, 2008. A Jewish family gathers during Passover while the Iranian soccer match plays in the background.

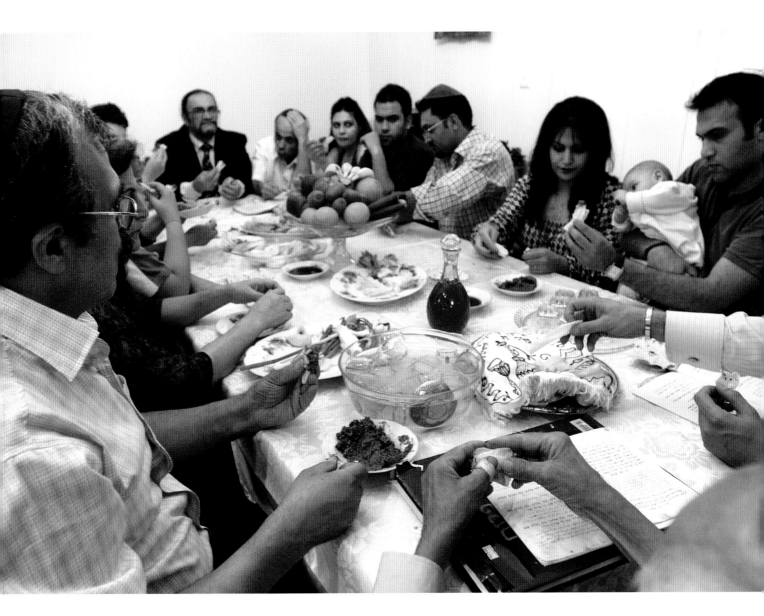

FIGURE 57 Tehran, 2008. Passover Seder at the Aframian family household in Tehran. The oldest member of the family reads from the Haggadah to start the meal.

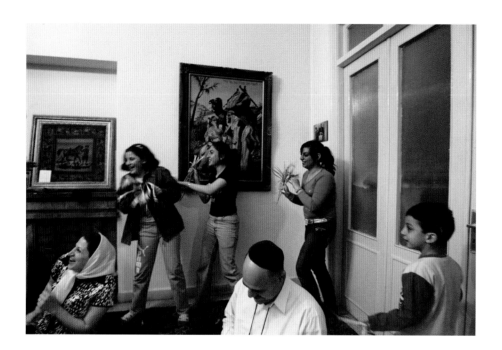

FIGURE 58 Tehran, 2008. During a traditional Passover celebration in Iran, Iranian Jews beat each other with green onions as a reminder that they should never long for Egypt or what it represents. Other traditions explain that the beating is a reenactment of the treatment of Jews by their slave drivers. For most Iranian Jewish kids, Passover signifies the only time of the year when lightly beating one's parents is deemed acceptable. This tradition is observed by Jews in Iran as well as by many Iranian Jews living in the United States and Israel.

FIGURE 59 | OPPOSITE Tehran, 2008. The Aframian family engages in the traditional Passover tradition of beating one another with green onions. Iranian Jews cover the seder table during the reading of the ten plagues to "shield" the brakha (blessing) of the seder from the plagues.

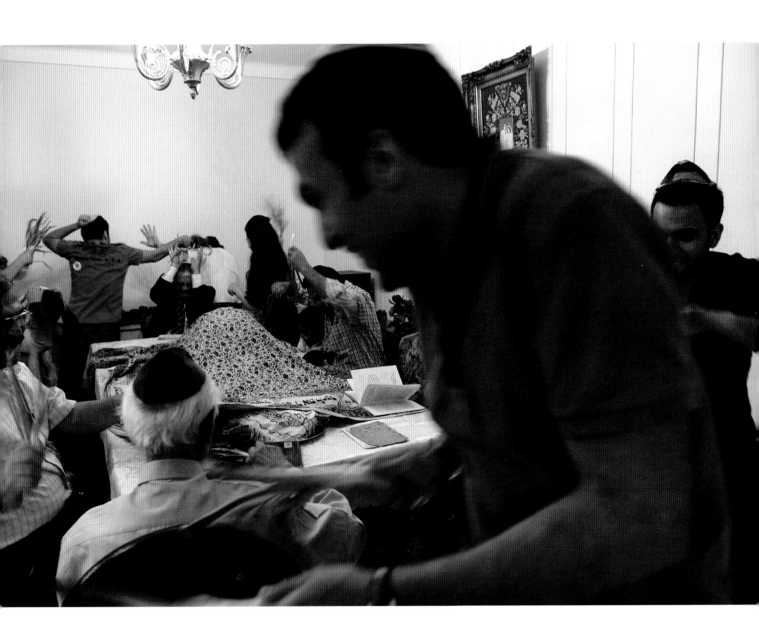

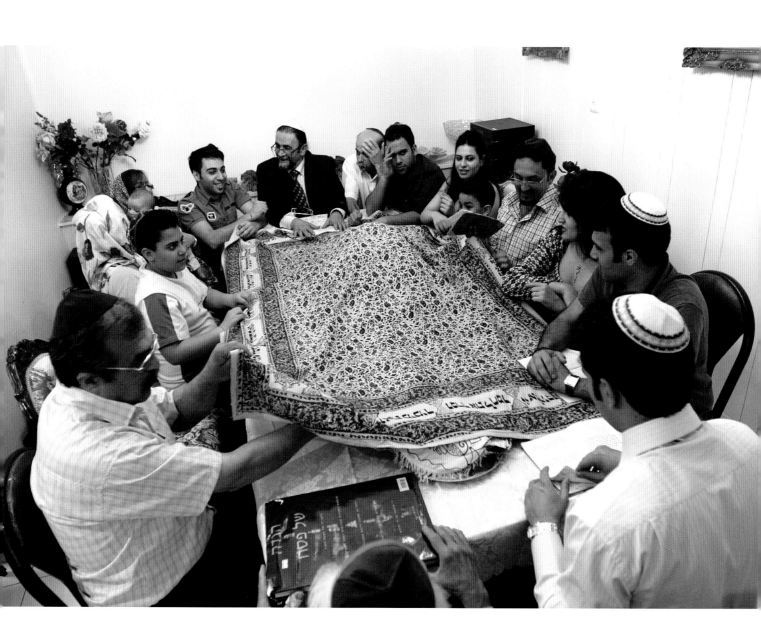

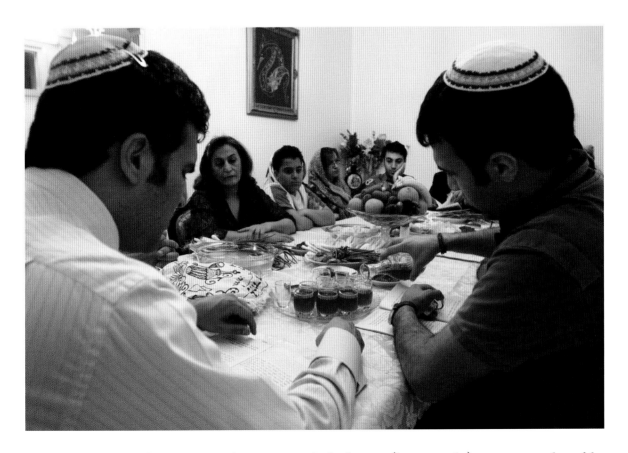

FIGURE 60 | OPPOSITE Tehran, 2008. Farhad Aframian (bottom right), a young member of the family, reads a part of the Haggadah with his uncle. During readings of the religious texts, they cover food with a tablecloth embroidered with Hebrew words.

FIGURE 61 Tehran, 2008. Farhad Aframian (left) reads from the Haggadah as his brother (right) pours wine during the Passover Seder.

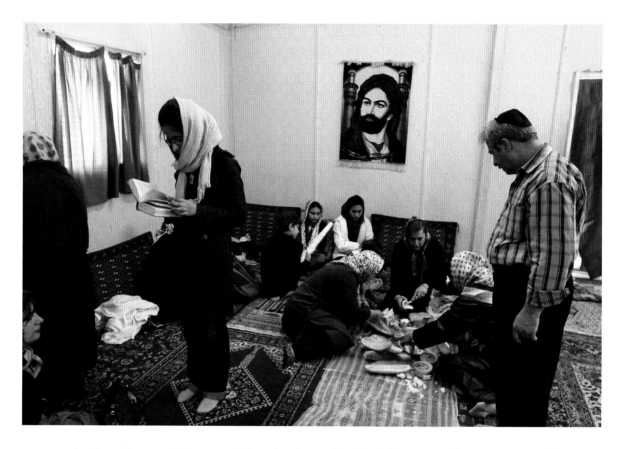

FIGURE 62　Hamedan, 2008. A group of Jewish pilgrims has breakfast in a Muslim mosque on the way to visit the tomb of Esther and Mordecai in Hamedan. Esther and Mordecai are the protagonists of the Purim story, which takes place in ancient Iran and serves as an important chapter in Iranian Jewish history. It is interesting to note the image of Imam Ali (the fourth caliph and the second most important figure in the Shiʾa tradition, after the Prophet Muhammad) on the wall above them.

FIGURE 63 | OPPOSITE　Near Hamedan, 2008. Two Jewish pilgrims from Tehran, Parviz Minaee (left) and Masoud David (right), tie the tefillin on each other in a Muslim mosque near Hamedan. A picture of Ali, the first Shiʾa imam, is seen on the wall behind them. This photo reveals the story of the religious sphere in Iran and the story of Iran itself in a way that a thousand words could not.

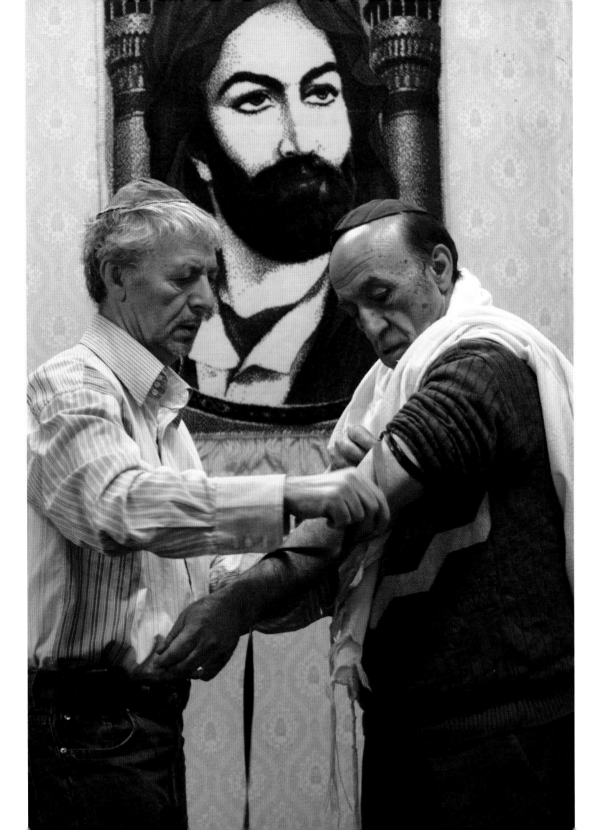

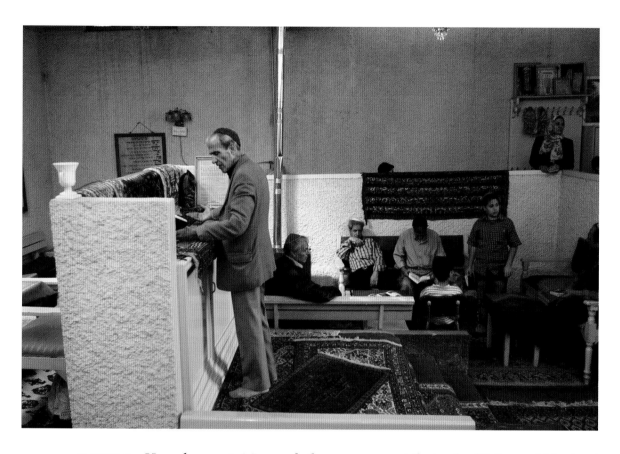

FIGURE 64 Hamedan, 2008. A Jew reads the noon prayer at the tomb of Esther and Mordecai.

FIGURE 65 | OPPOSITE Tehran, 2007. Two Iranian Jews visit a grave at the Beheshtieh Jewish Cemetery. Persian poetry covers the gravestone.

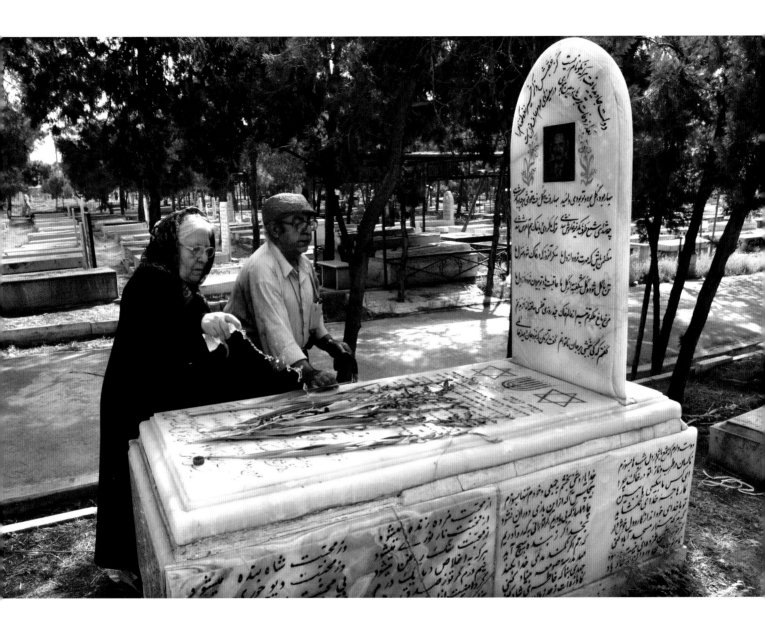

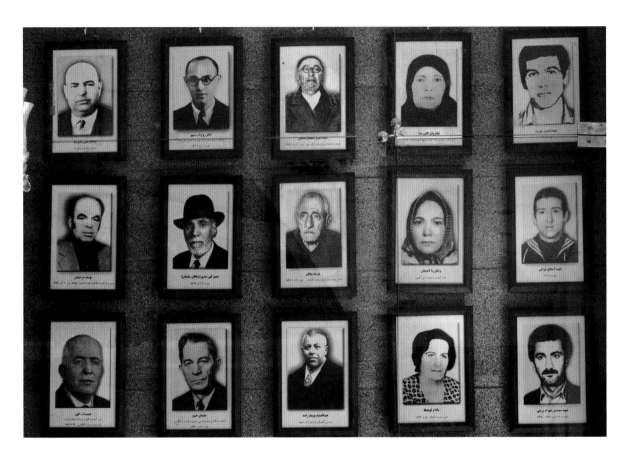

FIGURE 66 Tehran, 2007. Pictures of famous Jewish leaders seen at the funeral home at the Beheshtieh Jewish Cemetery.

FIGURE 67 | OPPOSITE Near Hamedan, 2008. Young Jews from Tehran smoke a hookah on the way back from visiting the tomb of Esther and Mordecai in Hamedan.

FIGURE 68 Near Hamedan, 2008. Jewish pilgrims from Tehran eat lunch in the park. Because there are few kosher restaurants in Iran, during long-distance travel, Iranian Jews pack meals. This also saves time and is more efficient for feeding a large group of pilgrims.

FIGURE 69 │ OPPOSITE Tehran, 2008. Gidaian's family reads a blessing over the Hanukkah lights in their home in Tehran. Hanukkah commemorates the miracle of the oil in the Temple in Jerusalem that took place in the days of the Second Temple, when Jerusalem was under the rule of the Hellenistic king Antiochus III. Judah Maccabee led a rebellion, and after they drove Antiochus's forces out of Jerusalem, Judah and his followers started to cleanse the Temple by removing the altars to other gods and religiously impure sacrifices. As they were rededicating the Temple, they realized that they had enough untainted olive oil for the menorah for only one day. Miraculously, this amount of oil kept the menorah lit for eight days, until they were able to bring pure oil from another region. On Hanukkah, Jews light eight candles over the course of eight nights (starting with one and lighting one more each night). The candles are lit by the *shamash* (the candle at the center of the menorah, taller than the others), and so on the eighth night of Hanukkah the menorah has a total of nine burning candles.

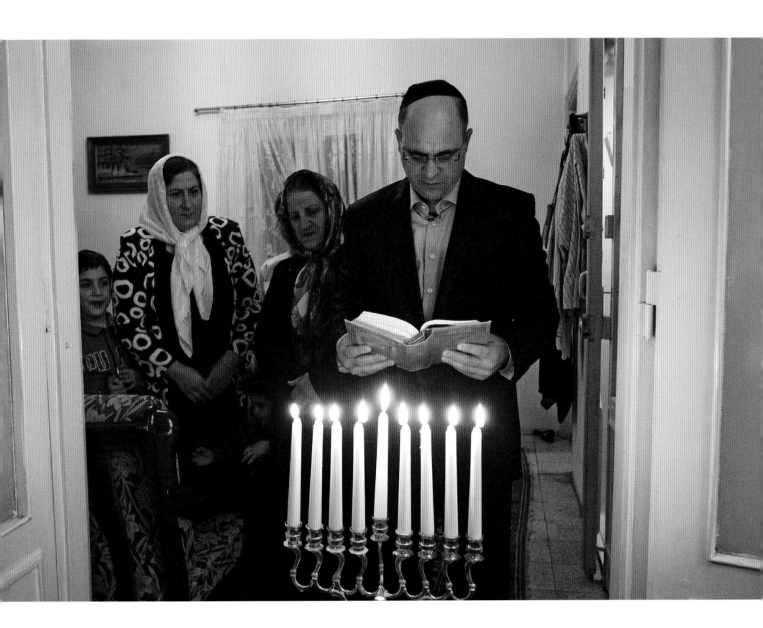

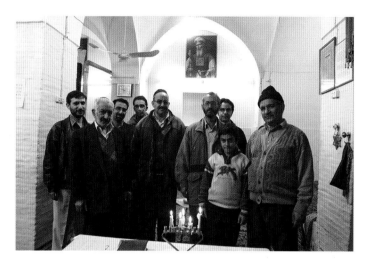

FIGURE 70 Yazd, 2008. A group of Jews poses for a photo during a Hanukkah ceremony.

FIGURES 71 AND 72 | BELOW | OPPOSITE Isfahan, 2007. Jews at daily prayer in the Jacob Synagogue of Joobareh. Popular lore, has it that the first Jewish settlers in Iran settled in Isfahan, which originally bore the name Yahideh. The area around this synagogue is believed to be the first place Jews settled upon their arrival in Iran 2,700 years ago.

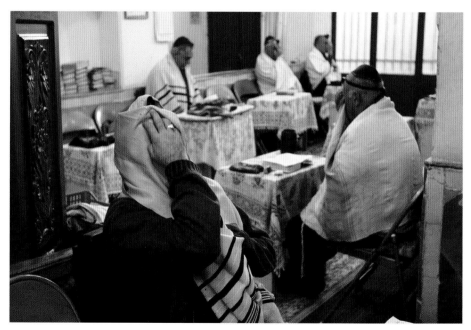

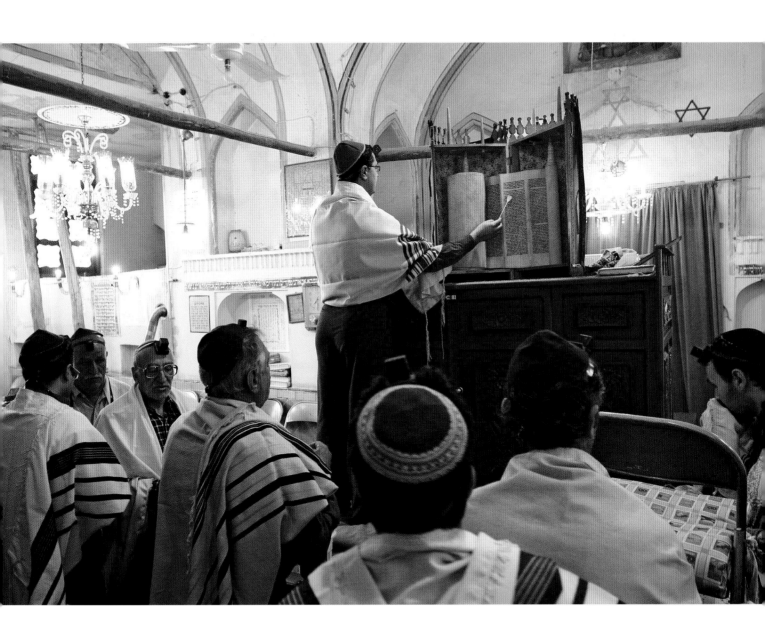

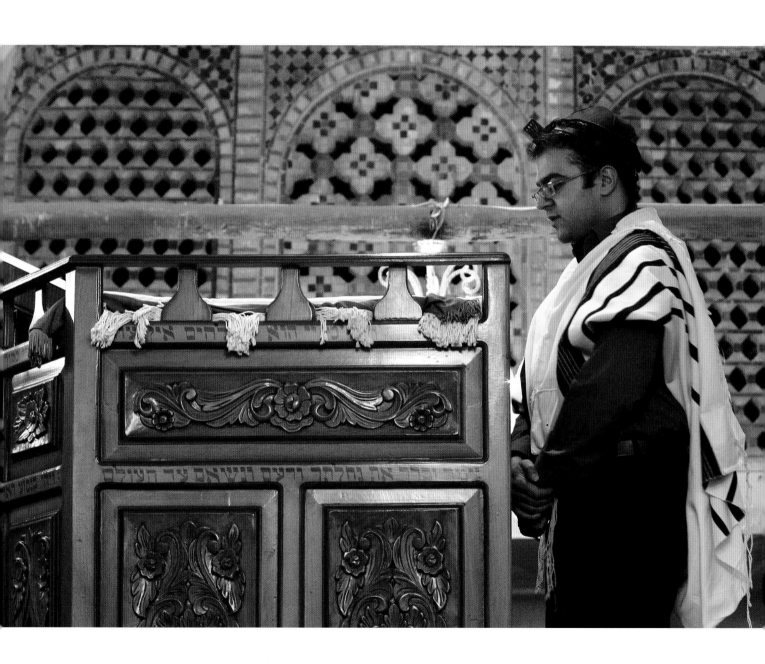

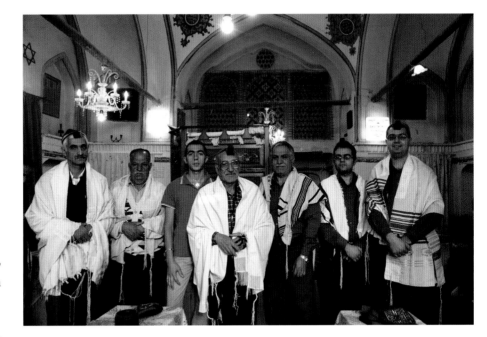

FIGURE 73 | OPPOSITE Isfahan, 2007. Musa Aframian reads from the Torah at daily prayer.

FIGURES 74 AND 75 Isfahan, 2007. Members of the Jewish community in Isfahan photographed inside an old synagogue.

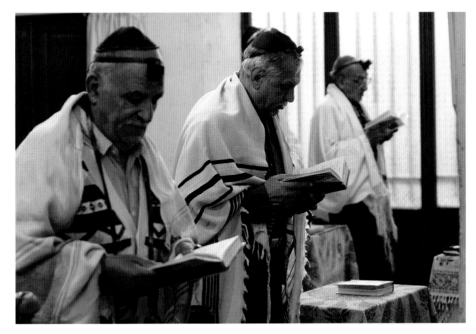

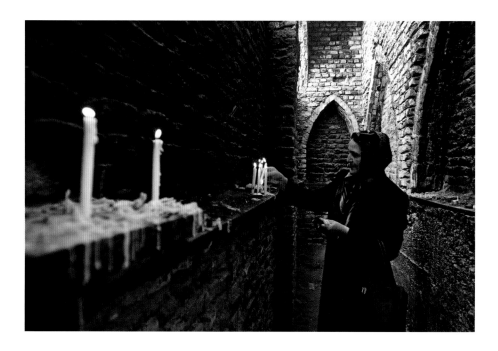

FIGURE 76 Isfahan, 2007. Zoleikha lights candles in the tomb of Serah bat Asher in a suburb of Isfahan. Serah bat Asher was the daughter of Asher, son of Jacob. She is one of the seventy members of the patriarch's family who emigrated from Canaan to Egypt, and her name appears in the census taken by Moses in the wilderness. Common lore claims that she is buried in Pir-e Bakran, a village near Isfahan. It is surrounded by a Jewish cemetery.

FIGURE 77 | OPPOSITE Isfahan, 2007. Homayoun Aframian reads prayers in the cemetery near Serah bat Asher.

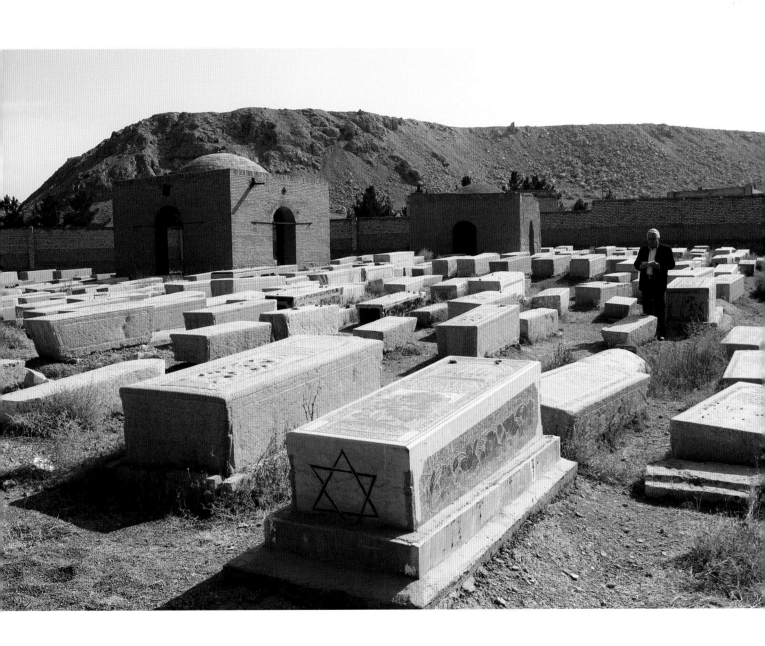

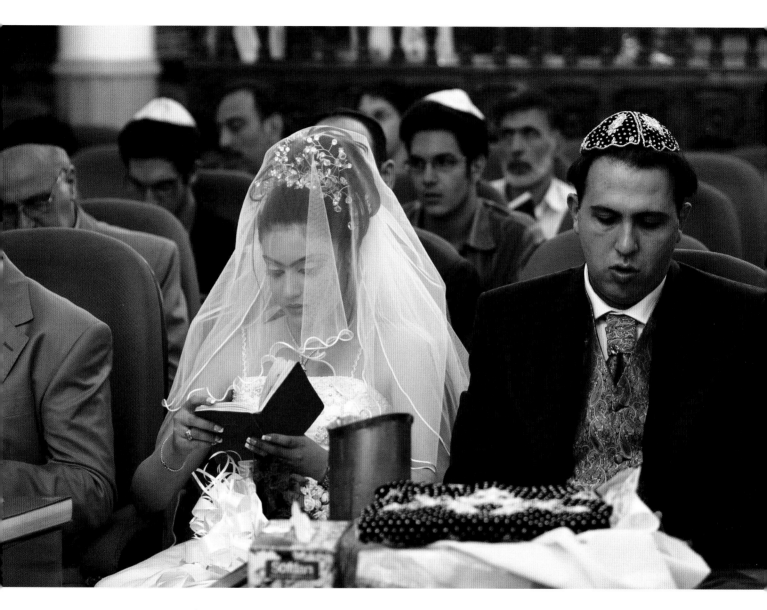

FIGURE 78 Tehran, 2007. Peyman Saketku, groom, and Sanaz Meriverzadeh, bride, read from a siddur during their wedding ceremony in the Yousef Abad Synagogue.

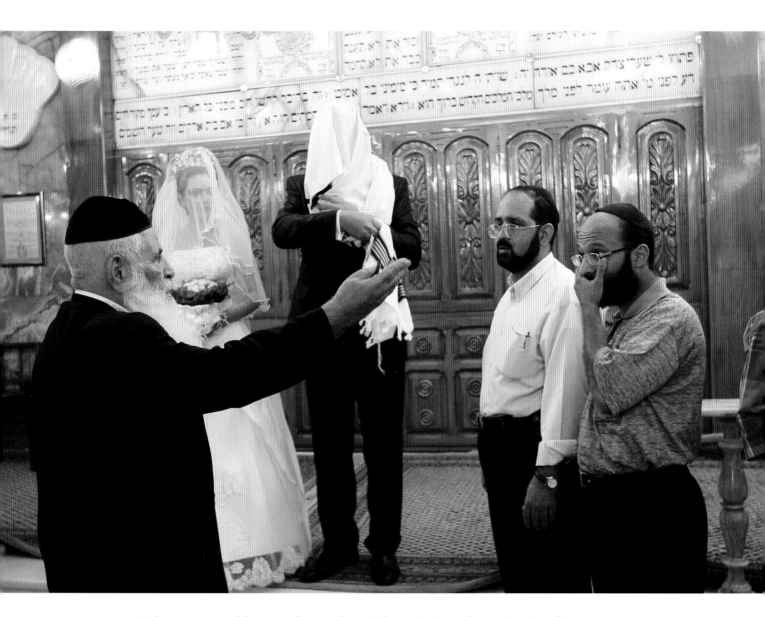

FIGURE 79 Tehran, 2007. Rabbi Yousef Hamedani Cohen, the late religious leader of the Iranian Jews, officiates this wedding as the groom, Peyman Saketkhu, and the bride, Sanaz Meriverzadeh, stand together. It is customary among Mizrahi Jews for the groom to receive a new *tallit* (prayer shawl) on his wedding day. When men say the blessing over the wearing of the tallit, they cover their faces.

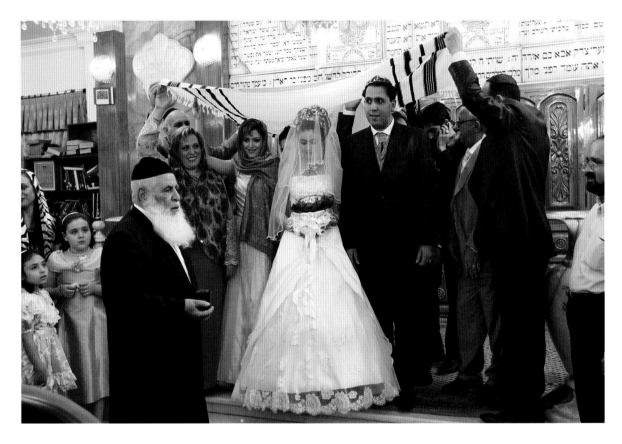

FIGURE 80 Tehran, 2007. The Jewish wedding ceremony of Peyman Saketkhu and Sanaz Meri-verzadeh. According to custom, the groom and the bride stand under a *chuppah* (canopy), a cloth or sheet—or sometimes a tallit—stretched over four poles. A chuppah symbolizes the home that the couple will build together. Among Iranian Jews the chuppah is traditionally a tallit that is held over the bride and groom by close and honorary members of the family.

FIGURE 81 | OPPOSITE Damavand, 2008. An old gravestone in Gilaad's cemetery in Damavand, Iran.

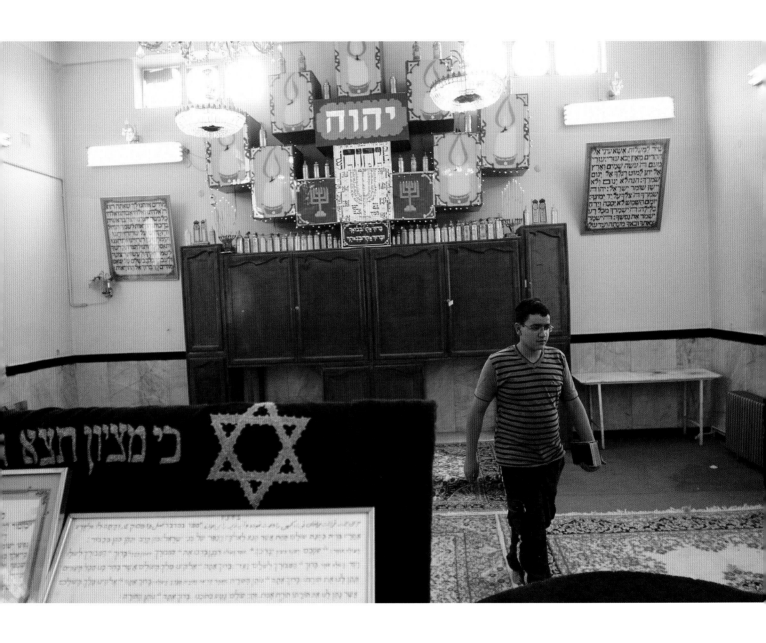

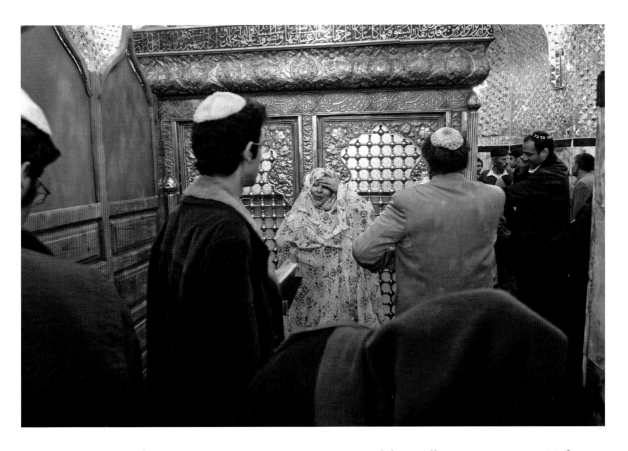

FIGURE 82 | OPPOSITE Kerman, 2007. A young Jewish boy walks into a synagogue. Today it is estimated that around fifty Jews remain in this neighborhood in Kerman.

FIGURE 83 Susa, 2008. The inside of the tomb of the prophet Daniel in Susa. Every year, many Iranian Jews travel to Susa to visit the tomb. Because the tomb is run by the Islamic Republican government, the pilgrims need permission to enter. Typically, the administration allows Jews to freely enter most of the tomb. In this photo, a group of Jewish men is seen with a Muslim woman—a friend who traveled with them and believes visiting Jewish holy places brings good luck.

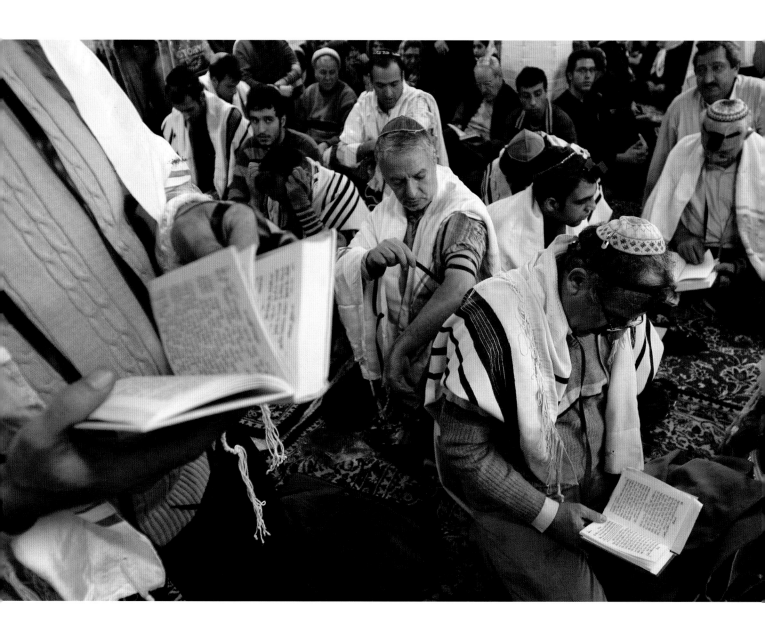

FIGURE 84 | OPPOSITE Susa, 2008. Jewish men in Susa prepare for their prayers. Parviz Minaee (middle) ties his tefillin.

FIGURE 85 Susa, 2008. A tefillin constructed using old Iranian methods and designed with traditional motifs.

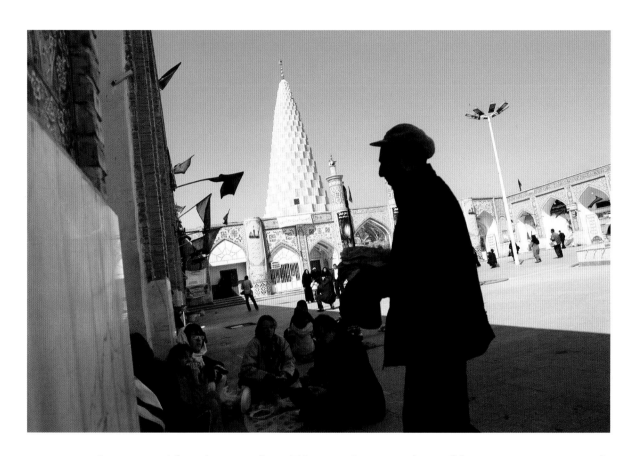

FIGURE 86 Susa, 2008. After a long trip from Tehran to Susa, members of the community sit outside the tomb of the prophet Daniel to have their breakfast. Although Daniel is a Jewish prophet, the tomb is decorated with Islamic symbols, and Muslims manage his tomb.

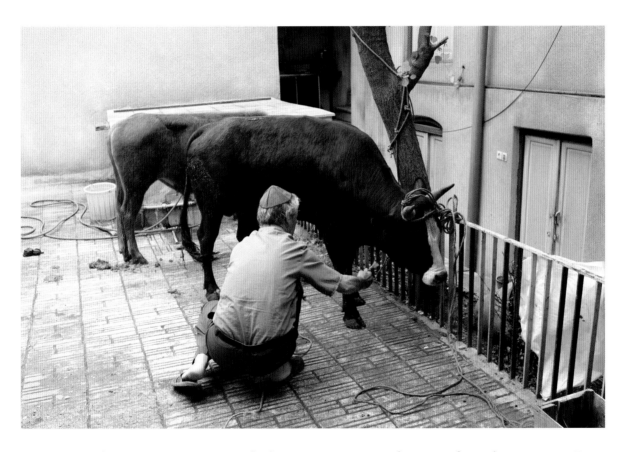

FIGURE 87 Tehran, 2008. Parviz Minaee feeds a cow in preparation for its sacrifice at the synagogue. Every year, around Rosh Hashanah, the community sacrifices cows and sheep and donates the meat to the poor.

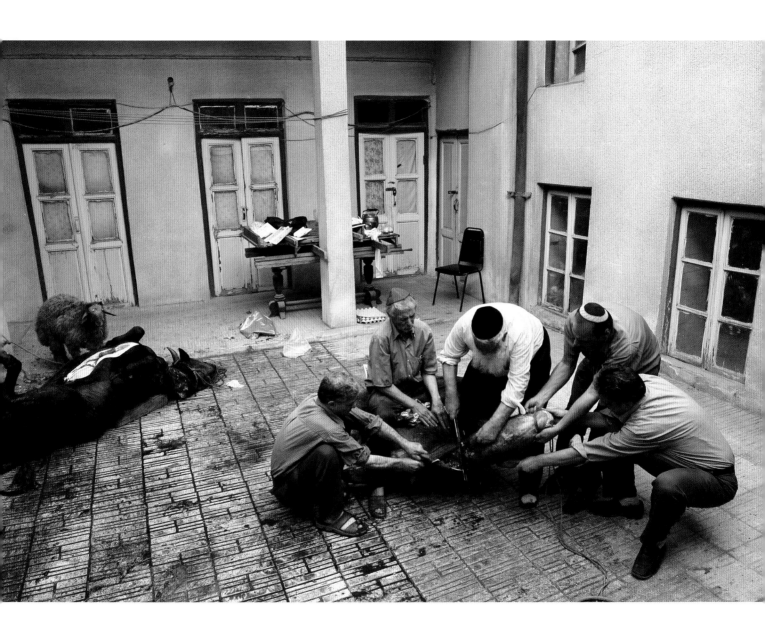

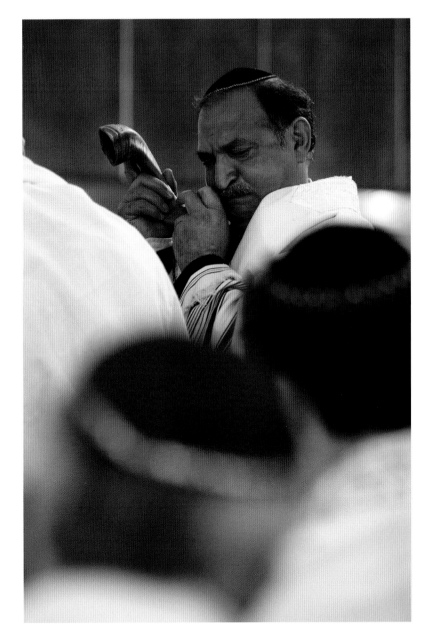

FIGURE 88 | OPPOSITE Tehran, 2008. At the Mashhadiha Synagogue, Rabbi Yousef Hamedani Cohen and other community members slaughter a cow for the poor.

FIGURE 89 Tehran, 2007. Yousef Sheibani blows the *shofar*, a ram's horn, at the Pesyan Synagogue.

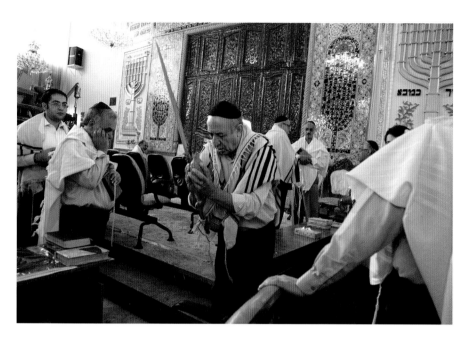

FIGURE 90 Tehran, 2007. Sukkot (also known as the Feast of Tabernacles) is one of the holidays that follow Rosh Hashanah in the month of Tishrei. This holiday commemorates the forty-year journey in the desert after the exodus from Egypt. On each of the holiday's seven days it is mandatory to shake "the four species": *etrog*, the fruit of a citron tree; *lulav*, a ripe, green, closed frond from a date palm tree; *hadass*, boughs with leaves from the myrtle tree; and *aravah*, branches with leaves from the willow tree. This photo shows the waving ceremony being performed in a synagogue.

FIGURE 91 | OPPOSITE Tehran, 2007. A gravestone in the Polish section of the Jewish Cemetery in Tehran. In the 1940s, hundreds of thousands of Polish refugees found shelter in Iran, among them many Jews. Many died upon arrival owing to poor health conditions, but many others overcame them and lived in Iran until the 1970s. Amid this massive wave of immigrants was a group that came to be known as the Children of Tehran, 780 Jewish orphans who came to Iran from Poland via the Soviet Union. The Children of Tehran, after a brief stay in Iran, were transported to Mandatory Palestine.

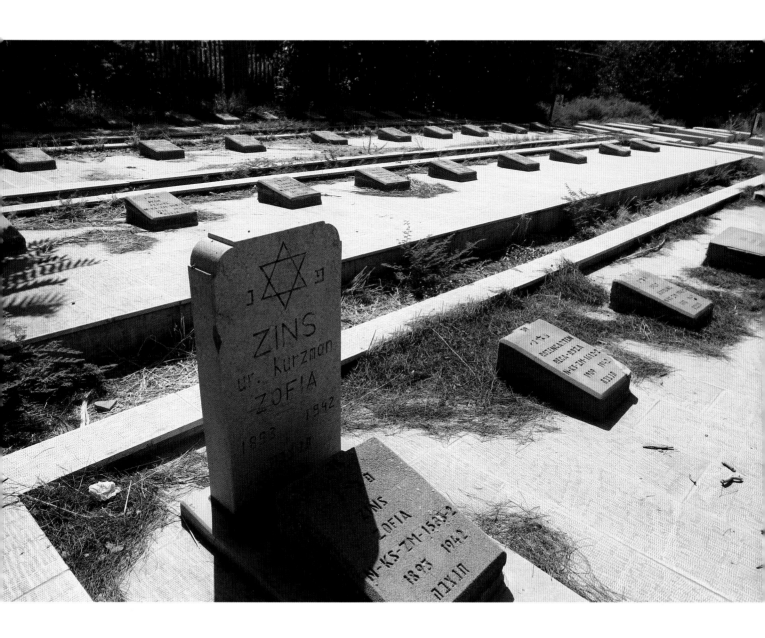

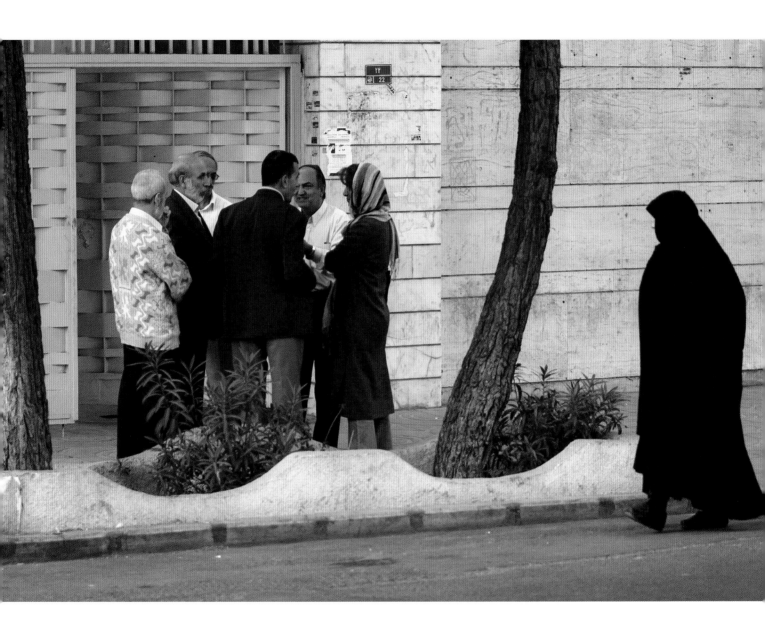

FIGURE 92 | OPPOSITE Tehran, 2007. A group of Jews speaks outside the Yousef Abad Synagogue after daily prayer.

FIGURE 93 Tehran, 2007. Shamsi, an elderly Jewish woman, lives with two other members of the community inside the Ezra Jacob Synagogue, in Tehran's mahalleh Oudlajan.

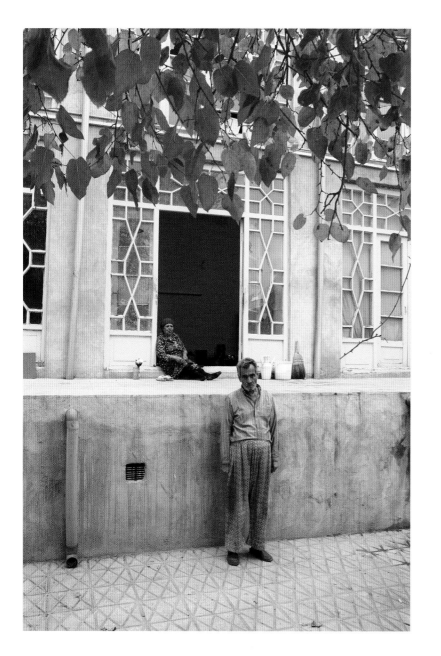

FIGURE 94 Tehran, 2007. Behanam, an older Jewish man, resides alongside Shamsi inside the Ezra Jacob Synagogue. Both Shamsi and Behanam said they could not live anywhere else.

FIGURES 95 AND 96 | OPPOSITE Yazd, 2007. Iranian Jewish pilgrims in an old synagogue.

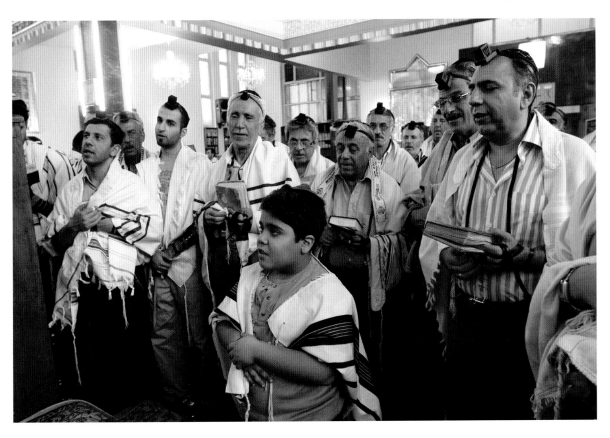

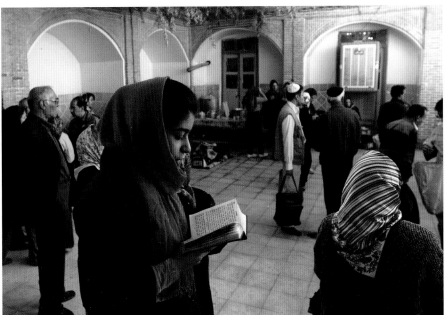

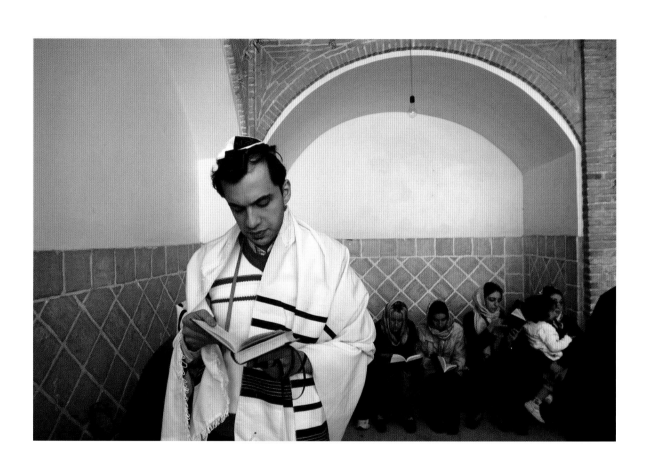

FIGURE 97 | OPPOSITE Yazd, 2007. Iranian Jewish pilgrims in an old synagogue in Yazd. A man begins his prayers.

FIGURE 98 Yazd, 2007. Iranian Jewish pilgrims in an old synagogue in Yazd.

FIGURE 99 Yazd, 2007. On the door of a synagogue in Yazd, the word *Jood*, a derogatory name for Jews, is written in graffiti, most likely an act of vandalism.

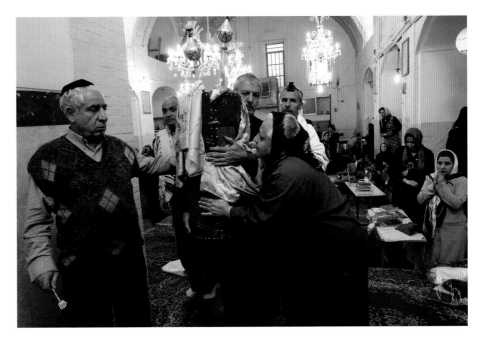

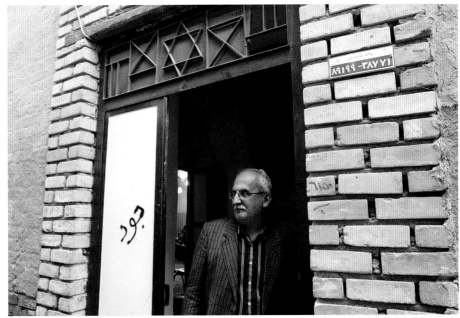

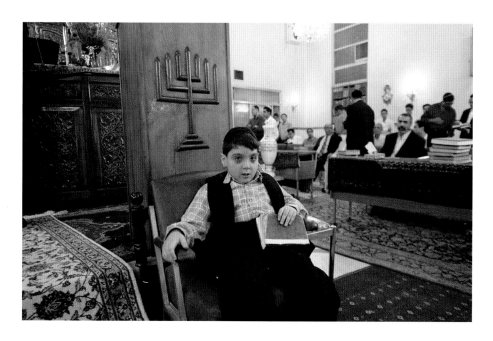

FIGURE 100 Tehran, 2000. A young Iranian Jew sits during a daily ritual in the Yousef Abad Synagogue.

FIGURE 101 Tehran, 2000. Iranian Jewish women at the Abdullahzadeh Synagogue.

Conclusion

As of August 2020, aside from Israel, Iran is the only country in the Middle East with a substantial Jewish community. (There are much smaller communities in Turkey, Yemen, and Egypt, as well as in Morocco and Tunisia in North Africa.) As this photographic journey shows, Iranian Jews lead full and complicated lives in the Islamic Republic of Iran. They navigate between the different sets of expectations of Israel, the international community, and their homeland of Iran. They work, travel, and worship as Iranians and Jews, without compromising one or the other identity. This book takes us on a poignant journey into their homes, shops, community events, synagogues, and pilgrimages, and it illuminates the deep connection that they have to their land, society, and language, even if it has been somewhat more difficult in the past forty-odd years. But what are four decades in a history of 2,700 years?

To understand Iranian Jewish life in the twenty-first century, we must listen to their voices and read their writings and avoid making assumptions based on global politics or media-led narratives. Iranian Jews are not locked behind an iron curtain, as it is often presented. It is true that in the 1980s leaving Iran was hard—almost impossible. There were restrictions on every Iranian, and for many reasons it appears to have affected Jews disproportionately. However, those days are mostly gone. They travel abroad—to Europe, to the United States, and sometimes even to Israel. They live in Iran today not because of a decision they made thirty or forty years ago; they live in Iran because they decide every morning to stay in Iran, or, to put it in Roya Hakakian's words from her beautiful memoir *Journey from the Land of No*: "The family dreamed of the land of milk and honey but wanted to wake up in Tehran" (Hakakian 2004, 52). This book, I believe, sheds light on the special connection between Iranian Jews and their country.

Bibliography

Abramovitch, Stanley. 1951. "AJDC Tehran to AJDC Paris." American Jewish Joint Distribution Committee Archives, Jerusalem, AR (1945–54), 505.

Afary, Janet. 1996. *The Iranian Constitutional Revolution, 1906–1911: Grassroots Democracy, Social Democracy and the Origins of Feminism*. New York: Columbia University Press.

Ahmad, Jalal Al-e. 2017. *The Israeli Republic*. Brooklyn: Restless Books.

Goldman, Mordechai. 2020. "Chief Rabbi of Iran: Israel Does Not Represent Judaism." *Al-Monitor*. https://www.al-monitor.com/pulse/originals/2020/06/israel-iran-qasem-soleimani-jewish-community-coronavirus.html.

Hakakian, Roya. 2004. *Journey from the Land of No: A Girlhood Caught in Revolutionary Iran*. New York: Three Rivers Press.

Isḥaqyan, Ilyas. 2008. *Hamrah Ba Farhang: Gushahʾi Az Tarikh-i Muʾassasah-i Alyans Dar Iran / Khaṭirat-i Ilyas Isḥaqyan*. Los Angeles: Sina.

Levī, Ḥabīb. 1999. *Comprehensive History of the Jews of Iran: The Outset of the Diaspora*. Costa Mesa, CA: Mazda.

Menashri, David. 1991. "The Jews in Iran: Between the Shah and Khomeini." In *Anti-Semitism in Times of Crisis*, edited by Sander Gilman, 353–72. New York: New York University Press.

Sarshar, Houman (ed.). 2002. *Esther's Children: A Portrait of Iranian Jews*. Philadelphia: Jewish Publication Society.

Sternfeld, Lior. 2014. "The Revolution's Forgotten Sons and Daughters: The Jewish Community in Tehran During the 1979 Revolution." *Iranian Studies* 47 (6): 857–69.

———. 2018. "'Poland Is Not Lost While We Still Live': The Making of Polish Iran, 1941–45." *Jewish Social Studies* 23 (3): 101–27.

———. 2019. *Between Iran and Zion: Jewish Histories of Twentieth Century Iran*. Stanford: Stanford University Press.

Index

emigration. *See* migration
Eshaqian, Elias, 6
Esther, 78
Esther, book of, 64, 66
Esther and Mordecai, tomb of, 78, 80
etrog, 104. *See also* rituals and holidays
exodus. *See* migration
Ezraeel (political pun), 40, 41
Ezra Jacob Synagogue, 107–8. *See also*
 synagogues

fascism, 3–4
feasts, 64, 104. *See also* rituals and holidays
food: community centers and, 45;
 donations of, 44; herbs in, 18; at kosher
 restaurant, 39; matzah, 67–68; Passover
 and, 70, 73–76; on pilgrimage, 84

Gidaian, Hertzl, 35
Gidaian family, 70, 85
Gilaad cemetery, 95. *See also* cemeteries
graffiti, 40, 41, 111
gravestones: cultural fusion and, 13; images
 of, 29, 81, 95, 105; of Polish refugees,
 11, 105
green onions, 74–75. *See also* Passover
grooms, 92–94

hadass, 104. *See also* rituals and holidays
Haggadah, 6, 73, 76–77
Haim, Ghodratallah, 26
Haim, Levi, 26, 27
Haim, Soleiman, 27
Hakakian, Roya, 6–7, 113
Haman, 64
Hamedan, 78, 80, 83
Hanukkah, 84–86. *See also* rituals and
 holidays
Haroun (Yazd resident), 36
Hayyim, Shmuel, 3
healthcare, 8, 13–14, 34
Hebrew School. *See* Jewish schools
herbs, 18. *See also* food
holidays. *See* rituals and holidays

Holocaust, 12
homeland, Jewish. *See* Israel, Land of
hookah, 83
House of Elders (Pir Khaneh), 19–22

identity, Iranian Jewish: and Israel,
 separation from, 45, 50, 54, 55; and
 Israel and Iran, fusion of, 7, 9, 11, 113;
 Zionism and, 2–3, 5–6
identity, Iranian national, 3, 5, 9
immigration. *See* migration
Intelligence Ministry, 14, 15, 16, 58
Iran: business and trade in, 6, 29;
 constitutional revolution of, 2, 49;
 history of Jews in, 1–4, 10, 78, 86,
 113; Iraq, war with, 9–10; Israel,
 demonstrations against, 55, 57; Israel,
 tensions with, 1, 9, 10, 11–12, 50, 54;
 Jewish communities in, 113; nation
 building in, 3, 5, 9; Polish refugees in,
 11, 34, 104; Sarbakhshian's experience
 in, 11–14; Vahidmanesh's experience in,
 14–16. *See also* revolution of 1979
Iranian Communist Party, 3
Iranian Jews. *See* Jews, Iranian
Iran-Iraq War (1980–88), 9–10, 13, 29
Isfahan, 38–40, 45, 86–89, 90–91
Islamic consultative assembly, 50–51
Islamic Republic of Iran: annual
 celebration of, 47; establishment of, 7,
 8; Iran-Iraq War and, 9; Israel and, 12;
 Jewish loyalties and, 54; Jewish rights
 and, 50. *See also* Iran
Israel: graffiti and, 40, 41; Iran, economic
 relations, 6; Iran, tensions with, 1, 9, 10,
 11–12, 50, 54; Iranian demonstrations
 against, 55, 57; Iranian Jews and, 45,
 50, 54, 113; Iranian nationalism and,
 5; United States and, 8; Zionism and,
 4–5, 6, 10
Israel, Land of (Jewish homeland):
 Iranian Jewish identity and, 1, 6–7, 11,
 45, 50; Zionism and, 2, 5
Ittefaq, 5. *See also* education

Jacob, 90
Jacob Synagogue, 86–89. *See also*
 synagogues
Jamiʿah-i rawshanfikran-i kalimi-yi Iran, 7–8
Jerusalem: Iranian Jewish identity and,
 6, 7; miracle of the oil in, 84; ritual
 practice and, 13; Ruz-e Quds, 12, 55. *See
 also* Israel, Land of
Jewish Agency, 6. *See also* Zionism
Jewish schools: identity and, 5; images of,
 23, 30–33, 60, 62; revolution of 1979
 and, 25. *See also* education
Jews, Iranian: business and everyday life
 of, 18–62; business and trade of, 27,
 29, 35; history of, 1–4, 10, 78, 86, 113;
 Iran-Iraq War and, 9–10; in parliament,
 2, 9, 10, 45, 49, 50; photographs of,
 explanation, 11–14, 15; population, 9,
 13, 16n2, 27, 41, 49, 97, 113; religious life
 and rituals of, 64–112; revolution of
 1979 and, 1, 7–8, 10, 11, 14; Zionism and,
 2–3, 4–6, 10, 41. *See also* cultural fusion
 and cooperation; education; identity,
 Iranian Jewish
Joobareh neighborhood, 45, 86. *See also*
 Isfahan
Journey from the Land of No (Hakakian),
 6–7, 113
Judah Maccabee, 84

Kemal Ataturk, Mustafa, 3
Kerman, 40–41, 96, 97
Khamenei, Ali, 32–33, 62
Khatami, Mohammad, 52–53
Khomeini, Ruhollah: death of, 49; house
 of, 54; images of, 32, 62; revolution
 of 1979 and, 7; Ruz-e Quds and, 55;
 Zionism and, 10
kosher food, 13, 39, 45. *See also* food
Kowsar School, 25. *See also* education

Larijani, Ali, 50
Los Angeles, 8
lulav, 104. *See also* rituals and holidays